GANDHARA

© 2001 Assouline Publishing for the present edition
601 West 26th Street, 18th floor
New York, NY 10001
USA
Tel.: 212 989-6810 Fax: 212 647-0005
www.assouline.com

First published by Editions Assouline, Paris, France.

Translated from the French by David Wharry.
Proofreading: Jennifer Dister

Color separation: Gravor (Switzerland)
Printed by Grafiche Milani (Italy)

ISBN: 2 84323 294 5

GANDHARA

The Memory of Afghanistan

BÉRÉNICE GEOFFROY-SCHNEITER

ASSOULINE

For my mother, Denise Geoffroy,
who painted Afghan skies so well...

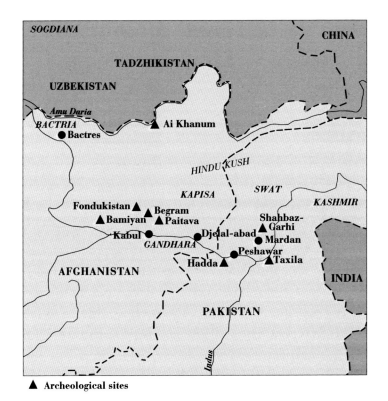

▲ **Archeological sites**

t he events which have irremediably shattered
Afghanistan have left the National Museum in Kabul in a
pitiful state. Today, its ripped-open roof, bricked-up
doors and windows, mutilated statues, smashed ceramics and
pillaged archives are guarded by a lone, imposing sentinel, the
headless statue of Kanishka, the Kushan sovereign whose vast
empire encompassed the ancient provinces of Bactria and
Gandhara in the second century A.D.

Have its forests of Buddhas with half-closed eyes, ecstatic smiles
and rippling drapery disappeared forever? Have its myriad stuccos
and terracottas immortalizing the sensual curves of a goddess or
the ambiguous grace of a bodhisattva vanished into thin air? Under
the hail of rocket fire, Afghanistan's memory continues to falter. In
the agony of its recent history, violence rivals absurdity. With each
passing day, an ancient civilization is giving way a little more to
barbarism.

Yet many a traveler has been beguiled by its harsh, snow-capped mountain landscapes, peerlessly luminous skies and the pride of its inhabitants with their noble, eagle-like profiles.

For Marco Polo, it was already a seemingly impregnable fortress of a land "whose every king is of the same lineage, a descendant of King Alexander and his wife, daughter of Darius the Great, the great lord of Persia." As for its inhabitants, "they are good archers and hunters, and most are dressed in animal skins for they are greatly lacking in other garments." Little did the ruggedness of their existence matter since, on top of their mountains, "the air is pure and staying there so invigorating that if a man living in the cities and dwellings built on the plain and in the valleys near to these mountains catches a fever of some sort or some other fortuitous illness, he need only go up into the hills for his disease to be banished and his health to return" ("The Description of the World," *The Travels of Marco Polo*, 1272).

But long before the intrepid Venetian, missionaries, merchants and pilgrims had already trodden its arid ground, drawb either by faith or by the "fabric from the land of Seres ("silkworm" in Greek), after which was named one of the richest trade routes in history, the mythical Silk Road. In turn, Iranians and Hellenes, Indo-Scythians, Chinese, Tibetans and Arabs established their supremacy on the fringes of these lands traversed by slow-moving caravans. Kingdoms and empires rose, only to disappear as quickly as a sandstorm in the desert.

Coalitions were formed, alliances came undone. There was the ever-present menace of marauding nomadic hordes, notorious for the grisly train of horror they brought with them. Yet in the shade of the oases, sovereigns and princes devoted themselves to life's ephemeral pleasures. The men of faith, monks and pilgrims who flocked there from far and wide, helped allay the perpetual fear

of invasion. Buddhism, which had emerged in north-eastern India in the sixth century B.C., with its pacific precepts, was by no means the only religion to appeal to these anxious souls. Nestorian Christianity and Manichaeism (which originated in Persia in the third century) took, with varying fortune, the same road as silk and gold.

What a strange theatre Central Asia was, swept by the bloodiest invasions and most fervent spiritual movements. Yet, in this harsh region encompassing present-day Pakistan and Afghanistan, in the first centuries A.D., there came about one of those little miracles that art history has sometimes worked: the magnificent and improbable encounter of the Greece of Alexander the Great and the India of Buddha.

●

"If, as I surmise, Kabul is not the Alexandria of the Caucasus, the latter cannot be far away." This, in the words of General Court, a former officer in Napoleon's army in service in the Orient, was the generally accepted opinion at the dawn of the 19th century. Whereupon the general cites the small town of Begram, in the Kuhestan region, "to which our eminent Orientalists should devote their utmost attention."

It was a region so rich in artifacts, that coins of all kinds seemed almost spontaneously to appear out of the ground. "The medals most commonly found there, and throughout Afghanistan, are Bactrian and Indo-Scythian," the French officer continues, "Persian, Parthian and Sassanian pieces are none the less common, which proves that this land was governed by kings of these dynasties."

The mythical Alexandria of the Caucasus was the mirage that generations of intrepid travelers, explorers and archaeologists versed in the classical literature secretly dreamed of wresting from the torpor of oblivion. One of the first westerners to entertain this rather arrogant idea was Charles Masson, adventurer by trade. Immortalized for posterity by his infamous nickname, "the stupa ripper," this British agent and part-time archaeologist had no qualms about digging out every Buddhist monument he came across, from which he extracted an impressive quantity of coinage, today residing in the British Museum in London.

"During the month of July 1833, I left the town of Kabul to explore the districts situated to the north of this town, at the foot of the Hindu Kush mountains, with the intention of determining the Alexandria ad Caucasum," he wrote in his journal. Flouting the ravages of war—English troops then had military control over the frontiers—and especially the violent marauders roaming rife in the region, Masson painstakingly drew every slightest section of wall and tiniest ruin, which very often proved to be a monastery or even a stupa.

Although the traveler was still hesitant about identifying the ancient city founded by the Macedonians in these far-flung climes, he was still convinced that he had located the "ruins of an ancient town of considerable size, extending over the plain known today as Begram, near the confluence of the Ghorbend and Pendjchir rivers and at the head of the great road leading from Khodjah Khedri in Kohistan to Nedjrau, Taghau, Lagham and Djelalabad. I soon learnt that a considerable amount of medals are collected every day on the plain of Begram"

The rest is history. In September 1922, an agreement was officially signed by the king of Afghanistan, Amanullah Khan, and the French government. It granted France exclusive excavation rights on Afghan territory for 30 years, during which French

archaeologists were to reign supreme throughout the land and make some of the most spectacular discoveries of the 20th century. For Alfred Foucher, eminent founder of DAFA (French Archaeological Delegation in Afghanistan), there could be only one priority; searching for the Greek origin of the mysterious art which had emerged at Gandhara. Did not the singular traits of its Buddhas have the grace and spirituality of the most beautiful Apollonian faces?

●

"It is above all at Begram-Kapisa that we should begin extensive excavations as soon a possible, given that we are sure the harvest will be a most interesting one," Foucher wrote in 1923, in one of his very first dispatches from Kabul. Nonetheless, excavations continued throughout the region.

Summoned from France by Foucher, Joseph Hackin succumbed in turn to the lofty beauty of the "Kingdom of the Blue," and savored the "infinite peace of the twilight of Islam."

His first steps took him to the ruins of the ancient fort at Balkh, then to Paitava, only seven miles from the Begram site. There, he unearthed a statuette which was original to say the least, a "Buddha executing the double Miracle of Water and Fire." Carved in a magnificent grayish-colored schist, today it resides in the Musée Guimet in Paris.

"On Saturday, December 20th it appeared, face first, new and all gold, sparkling in the rising sun. This is the beautiful golden glow in which legend has bathed the image of the Blessed One...."

But politics and archaeology, fraught with intermittent crises and misunderstandings, often made capricious bedfellows. It was not

until 1936 that the Begram area, long considered too dangerous, became available to archaeologists again.

The "Bazaar excavations," directed by Jean Carl and Jacques Meunier, quickly proved fertile. "Site 1" revealed structures of a town from the Kushan period (first through the third centuries), its narrow streets lined with craftsmen's booths. But "Site 2," entrusted to Ria, Joseph Hackin's wife, surpassed their wildest hopes.

In a few days, out of the bowels of the Begram earth came a treasure whose wealth and eclecticism testified to the extraordinary role this opulent central Asian city and crossroads once played. Carefully set on benches placed next to the walls, translucent glassware, delicately painted in the purest Alexandrian style, mingled with magnificent fish-shaped balsamaries and charming Hellenic bronzes and plaster emblemata (the medallions which served as models for apprentice artists or samples for prospective clients) of those staple subjects—maenads, Silenuses, satyrs and other benevolent Dionysian figures—so popular in the ancient world.

But the star attractions of this extraordinary gathering, were the priceless sculpted ivory plaques, definitely of Indian origin judging by their style and iconography.

Depicted in the ease of everyday life, young creatures flaunt their sensuous curves under the severe gaze of a helmeted Athena, cast in bronze. It is a perfect reflection of these regions, where the art of Alexander's Greece encountered the princely kingdom of Mathura, and Augustus' Rome met the nomadic world of the Kushans and the China of the Han Dynasty. Although Hackin never managed to complete his excavations (he and his wife died tragically during the Second World War), his discovery nevertheless shed new light on the existence of these "non-Mediterranean descendants of Greek art," to cite Daniel Schlumberger's now-famous phrase.

Cosmopolitan and hedonist Begram was by no means the only city to harbor the remnant of Afghan's past. Discoveries were made daily, with each new excavation dictated by the vagaries of the turbulent political climate. It was, as Joseph Hackin summed up in his journal in 1924, "archaeology practiced as a sport."

the paths of scholars sometimes cross those of adventurers, diplomats, artists, even industrialists, as the prosperous French firm Citroën's "Croisière jaune" (Yellow Cruise) along the roads of Central Asia and China so impressively illustrates. The mission of the first group, "Pamir," led by Georges-Marie Haardt, was to set out from Beirut for the Himalayas via Persia and Afghanistan. Joseph Hackin, only too glad to able to leave his post as curator of the Musée Guimet for a while, was accompanied by a hand-picked, elite party: Louis Audouin-Dubreuil, his companion of old; father Teilhard de Chardin, responsible for paleontology; Alexandre Iacovleff, the expedition's official painter; Maynard Owen Williams, a *National Geographic* reporter; the author Georges Le Fèvre and the filmmaker André Sauvage. After leaving Beirut on April 4, 1931, the Pamir group reached the Afghan frontier on May 20, where they were met with a sign reading: "Entry into the pure and pious land of Afghanistan is forbidden without a passport."

Nevertheless, King Nader Shah himself welcomed the members of the expedition with fanfare in his palace in the capital, Kabul. Dancing and feasting lasted for five days, and the painter and the filmmaker recorded for posterity the astonishing receptions held in their honor by the governor at Mokur. Warriors executed dances of

extraordinary violence, flailing their loose hair, their eyes silvered with antimony, their arms weighed down with bracelets. (One should not forget that in this country of harsh morals, the thief's ear is still nailed to the robbed person's door, adulteresses are stoned to death and babies are lulled to sleep with little balls of opium...)

A few days later, the Pamir group's excursion to Bamiyan was recorded for posterity by a magnificent photograph taken at the foot of the colossal Buddha to which the valley owes its renown. "Its golden colors sparkle in every direction and its priceless ornaments blind us with their brilliance," wrote the Chinese traveler Xuanzang when he visited the city in 632. In addition to the sumptuousness of the effigy carved out of the rock face, there was the splendor of the paintings. Bodhisattvas with mannered gestures sit on thrones adorned with embroidered fabrics next to musicians playing curved harps. A few yards away, another, slightly smaller Buddha stands in a vaulted niche, once entirely painted. At its zenith there is a representation of an Iranian-looking divinity, probably the sun god, Surya, depicted in the manner of Apollo, standing on a chariot drawn by four horses.

Joseph Hackin explained to his colleagues, who were surprised at the sorry state of these images, that Muslims, considering them heretical, had willfully damaged them. The faces had been furiously hammered, the paintings daubed with tar and burned, and the effigies of the Blessed One fired on at point-blank range.

Alexandre Iacovleff was hoisted up onto Buddha's head where, immune to vertigo, he tirelessly reproduced the frescoes on the vaults. "Interested in analyzing in greater depth the spirit of this art and in conserving some record of these paintings which the years will soon, unfortunately, efface all trace, I applied myself with emotion to the copyist's task," Iacovleff wrote in his travel journal. The painter went on to detail his method: "On a folding

stool perched on the colossal head's convex summit, I had to spend long hours working with my head bent back to decipher the flowing, vivacious lines, so pitted and wounded was the surface by time and the gunshots of fanatical Mohammedans."

After the murderous war years which have ravaged this region, just what remains of these jewels today? One shudders in horror at the very thought.

Nevertheless, there remains the memory of the thousands of monks and pilgrims who once knew this spectacular location with its luminous, crystal-clear skies, and the armada of anonymous painters who hollowed out its rock to adorn its walls.

far from the worldliness of the highly-publicized Croisière Jaune, the excavations at Hadda brought to light a little-known facet of Ghandaran genius. Jules Barthoux's team of archaeologists unhearthed a host of small stucco figures and heads, sculpted with extraordinary liveliness and apparently once many colored. Indian princes, Barbarian lords, servants, soldiers, ascetics, even demons with pointed ears comingle in the most unusual portrait gallery.

Standing out amongst this motley crew, mysterious and serene, are the beautiful calm faces of Buddhas with half-closed eyes and the sensual, impish faces of nymphs with sibylline smiles. This unprecedented and exceptionally rich haul was shared equitably between the Musée Guimet in Paris and the future Kabul Museum, founded in 1931. Fate would have it that only those pieces transported thousands of miles from their discovery site have escaped the convulsions of history.

But the event which was to literally revolutionize archaeology in these regions can be summarized in a single name, Ai Khanum. Located on a strip of land at the confluence of the Amu Daria (the Oxus in Antiquity) and Koktcha rivers, this vast city would amaze the DAFA archaeologists, both by its wealth of sculpted decoration and the sophistication of its urban development.

While out hunting King Zaher Shah (today living in exile in Rome) saw what he first took to be the capital of a column jutting out of the ground in the midst of the plain. The French archaeologists who were informed and immediately set out to inspect this strange fragment, as yet unaware of the import of the discovery: for centuries, in the heart of this harsh and hostile territory, had slept one of the mythical Alexandrias the great Macedonian general had founded following his conquest. Of this there could be no doubt. Ai Khanum, as it turned out to be, was a "Greek city," a Hellenic metropolis with, at the foot of its acropolis, its propylaea, gymnasium, palestra and theatre, all attesting to its "Greekness." Its ostentatious, even grandiloquent structures immediately struck the archaeologists. Everything seemed designed to assert the preeminence of the governing class: the gigantism of the palace courtyard, the ample size of the dwellings' reception rooms (amongst the largest in the entire Greek world), and the boxes reserved for the aristocracy on the theatre's terraces. The town's decoration was simply stupefying: fountains adorned with gargoyles, elegant Corinthia columned peristyles, and inscriptions carved in marble for the benefit of passersby—here, in this Eurasian city, lost on the frontier of the Greek world, could be read one of those Delphic maxims that were the glory of post-Socratic philosophy. Daniel Schlumberger and his team unearthed expressive faces, magnificent drapery fragments and naked arms and legs, all in the triumphant Hellenic style. One sculpture, left unfinished, immortal-

izes an ephebe crowned with foliage; a Hermaic pillar weds the outline of a hoary old man, proof that in these "barbarian" lands local craftsmen were sculpting in the Greek style, tirelessly copying the clichés reproduced on plaster emblemata or on the reverse of the finest Bactrian coins.

What became of Ai Khanum? Was it also engulfed in the throes of war? The city, whose name in Uzbek means "Lady Moon," was probably, according to research by the Hellenic scholar Paul Bernard, one of the most majestic Alexandrian cities of Bactria. Tragically, this fortified outpost commanding the road to China and wealthy emporium controlling trade in the highly-coveted lapis lazuli, died a second death when the French team was forced to leave in 1978.

althrough the weapons of war have replaced the archaeologist's spades, the memory of Afghanistan's glorious past still lives in its history and artifacts. Historians and aestheticians are constantly questioning this hybrid art that emerged on the borders of India and Iran. Hellenists concerned with emphasizing the influence of Greek heritage vie with Orientalists quick to situate Gandhara within a considerably larger sphere of influences. And the eminent scholar Mario Bussagli has pointed out Gandhara's debt to the Parthian and Sassanian worlds and the Kushan universe, too frequently reduced to the emblematic figure of Emperor Kanishka. Does not the history of these regions rest entirely on the fragile status quo between their sedentary and nomadic peoples?

Lost in their quarrels, the specialists almost forget the prime function of this singular art which emerged from the shadows of the

monasteries, forged by the hands of anonymous craftsmen driven by an enthusiasm equal only to their faith. Was it not supposed to convey, by means of those works whose virtues were as protective as they were edifying, the upholding of divine Law?

t here is nothing profane about these miles of frescoes with their expertly codified colors, or the concerted iconography of these processions of reliefs and sculptures. The artist is an instrument, his art a message. He employs the sublime, caricature, realism, stylization, even the macabre only for their effectiveness in expressing his vision.

For it was precisely in these regions of extreme climate, prey to brigands, mirages and storms, that one of the most singular images in the history of humanity was born: that of a prince who was transformed into a god known as Buddha, "the Enlightened One."

Here again, Hellenists and Indianists dispute the paternity of the first depiction of the Blessed in human form, attributing it respectively to Greece and India. Do we owe this ingenious invention to Gandhara's Hellenic milieu, which favored anthropomorphic representation of divinities?

It is true that, from the first century A.D., the Buddhas of these regions straddling present-day Afghanistan and Pakistan not only adopted Greek drapery but also the smile and features of the Olympians, whose successors under Alexander the Great retained confused traits: the chignon with wavy locks and the arch of the eyebrows directly prolonging the straight nose.

Or, in these earliest depictions of the Blessed, should one discern a fundamentally Indian creation, originating in the Mathura region?

There is no idealization in these robust effigies carved in pink stone, but rather a type revealing an undeniable kinship with the tree and water spirits, figures of the popular mythology of the time. On the one hand, the "spiritualized" body is concealed beneath the fluid drapery of the monastic robe, on the other, the stocky anatomy, bulging pectorals, accentuated penis and, above all, chubby face surmounted by a smooth, shell-like hairstyle.

but enough of these academic squabbles. The whole essence of Gandharan art resides precisely in its subtle blend of Indianity and Hellenism, of the art of the Steppes and classical canons. Such a language, sensual and intellectual, but also narrative and symbolic, could only have emerged in these fringe zones favoring both material and spiritual exchanges.

One Buddha is portrayed as a beautiful young man of Praxitelian grace; a second, obeying local custom, has a thin moustache; a third, a portrayal of rare power, depicts him emaciated after his long years of asceticism.

Again Mario Bussagli throws telling light on this. "The history of the extraordinary adventure of Greco-Hellenic art harnessed in the service of the Buddhist Word, is a story of adaptation, modification and transformation. Of metamorphosis, one could even say. Fundamentally, as André Malraux wrote in *The Voices of Silence*, it is the story of a liberating and emancipating contribution giving, to he who receives it, the means necessary to liberate himself from it." The great Italian scholar advances this daring hypothesis: "It seems to me very probable that the unknown artist who created the

initial model was a Yavana, an artist and philosopher, of both Greek and Indian culture. No matter who he was, in effacing the name of he who first imagined this very strange iconogram, history perpetrated one of the greatest injustices of which one can accuse the critical thought of humanity. Since it was in him, this Asian Greek, that became truly blended—thanks to his exceptional genius—the greatest cultures of Eurasian antiquity from the Mediterranean to the Himalayas, in all the scope of their experience and religious constructions." (*The Art of Gandhara*, 1996.)

Whether a genius or merely a modest journeyman, the Gandharan artist was above all the inventor of a delectable catalogue of imagery that would be copied for centuries to come by painters and sculptors in Central Asia and as far afield as China and Japan.

A microcosm of humanity—men, women, monks, ascetics, princes, beggars, soldiers, horsemen, barbarians, young children, angels and demons—would be preserved in all their glory by the magic of this unique art. And through one of those inexplicable affinities, the West would discover the marvelous grace of Hadda's most beautiful stucco faces.

Postscript:

No sooner had I voiced my alarm and fear in this little book entirely devoted to Afghanistan's ancestral culture than the terrible news broke. On February 26, 2001, the Taliban authorities announced that the Bamiyan Buddhas had been destroyed. Pulverized by shells and dynamite, these lone sentinels of Buddhism in the Islamic world had succumbed to the iconoclastic fury of a handful of religious fanatics. And the veil of mourning and obscurantism had been drawn yet further over this land bathed in tears.

Glossary

Blessed (the): Name by which Buddha is known.

Bodhisattva: Literally meaning "one whose essence is enlightenment." Royal or saintly being who temporarily renounces attaining Nirvana to help others to salvation.

Buddha: Literally meaning "the Enlightened." Originally, the epithet designating Sakyamuni, the prince Siddhartha, founder of Buddhism. Later, it applied to any being capable of attaining, by its spiritual power, a particular state enabling it to escape the cycle of successive rebirths.

Gymnasium: Greek term designating the building destined for the physical and intellectual education of young people.

Kushans: People of Central Asia, most probably Iranianized Scythians, who in the first century A.D. ruled over a vast empire including Bactria and north-west India.

Sakyamuni: Literally meaning "sage of the Sakya tribe" and one of the titles of the historic Buddha.

Sassanids: Persian dynasty which ruled from A.D. 225 to 652.

Siddhartha: Name of the historic Buddha when he was still a prince living in his father's palace.

Stupa: "Tumulus-reliquary" built around the ashes of a saintly figure. The Buddhist monument par excellence, probably originating in Gandhara.

Scènes de la vie de Bouddha

Le Bouddha eut beau fait de dénoncer l'idolâtrie, un cortège d'images vit le jour quelques siècles après sa mort, qui illustrèrent avec une verve inouïe la geste du Bienheureux dans ses moindres détails. La palme de l'inventivité revient, sans conteste, aux sculpteurs du Gandhâra. Savoureuses "bandes dessinées" avant la lettre, les plaques de revêtement de leurs stûpas allaient offrir, pour de longs siècles à venir, un prodigieux catalogue d'images et de modèles aux praticiens d'Asie centrale, de la Chine et du Japon.

Naissance et jeunesse du prince Siddhârta. IIᵉ-IIIᵉ siècle. Schiste. Swat du Sud. Musée Guimet, Paris. © RMN. *(en haut, à g.)*
Celui qui allait devenir "Bouddha" ("l'Éveillé") serait né vers le milieu du VIᵉ siècle avant notre ère, dans la principauté de Kapilavastu, à quelque 240 km de Bénarès, aux confins du Népal actuel. Sa famille était de caste guerrière et appartenait à la lignée des Gautama. La légende raconte que c'est sous la forme d'un éléphant blanc que le Bouddha entra dans le sein de sa mère. Ressentant les premières douleurs de l'enfantement, la reine Mâyâ s'appuya sur la branche d'un figuier : de son flanc droit jaillit miraculeusement le prince Siddhârta appelé au plus grand des destins…
Le Grand Départ. IIIᵉ siècle. Schiste. Pakistan. Musée Guimet, Paris. © Photo Jean-Louis Nou/AKG Photo. *(en haut, à dr.)*
Élevé par la sœur de sa mère (emportée sept jours après sa naissance par une fièvre maligne) et par son père, le roi Shuddhodana, le jeune prince mène alors une existence heureuse au palais. Il fait preuve très tôt d'une intelligence et d'une force hors du commun.

Cependant, quatre rencontres (un vieillard, un malade, un mort, un religieux) l'amènent à réfléchir sur la précarité et la souffrance de la condition humaine. À la vue des femmes endormies dans le palais (qui évoquent en lui le spectacle d'un charnier), Siddhârta renonce à sa condition princière pour devenir un religieux errant. Accompagné de son fidèle cocher Chandaka, il s'enfuit sur son cheval Kanthaka : c'est le "Grand Départ".

Bouddha en compagnie de disciples. III° siècle. Schiste. Musée Guimet, Paris. © Photo Jean-Louis Nou/AKG Photo. *(en bas, à g.)*
C'est dans le Parc aux gazelles de Sârnâth, non loin de Bénarès, que le Bouddha prononce son premier sermon et met en mouvement la Roue de la Loi. Pendant plus de quarante années, le Bienheureux fera entendre sa parole au hasard de ses pérégrinations et augmentera, de façon considérable, le nombre de ses fidèles.

Parinirvana de Bouddha. III° siècle. Schiste. Pakistan. Musée Guimet, Paris. © Photo Jean-Louis Nou/AKG Photo. *(en bas, à dr.)*
Sâkyamuni ne s'éteindra qu'à l'âge de quatre-vingts ans (probablement vers 480 av. J.-C.) à Kusînagara, le Kasia actuel. Sa mort, au milieu de ses fidèles, rappelle à bien des égards celle d'un autre sage de l'Antiquité, Socrate. De même que le philosophe grec interdit à ses disciples de le pleurer, Bouddha exhorta ses proches à ne pas désespérer. On remarque pourtant, sur ce bas-relief du Gandhâra, la douleur d'un assistant qui se lamente, les bras levés vers le ciel, selon le vieux schéma attesté en Asie centrale. À moins que cela ne soit là un souvenir du rituel des antiques pleureuses grecques...

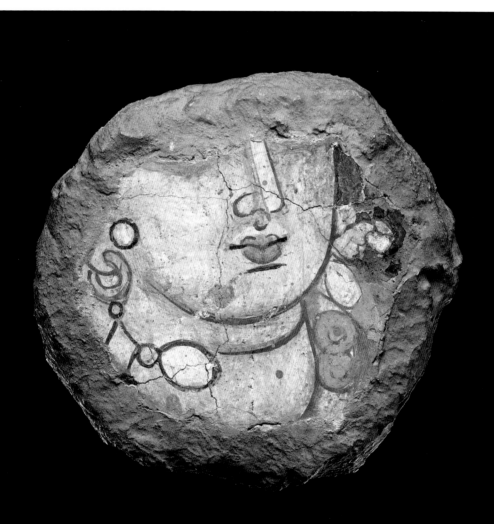

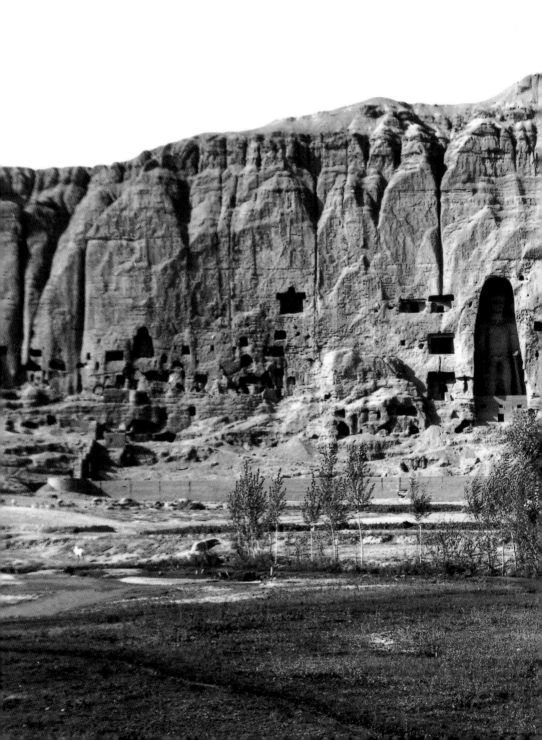

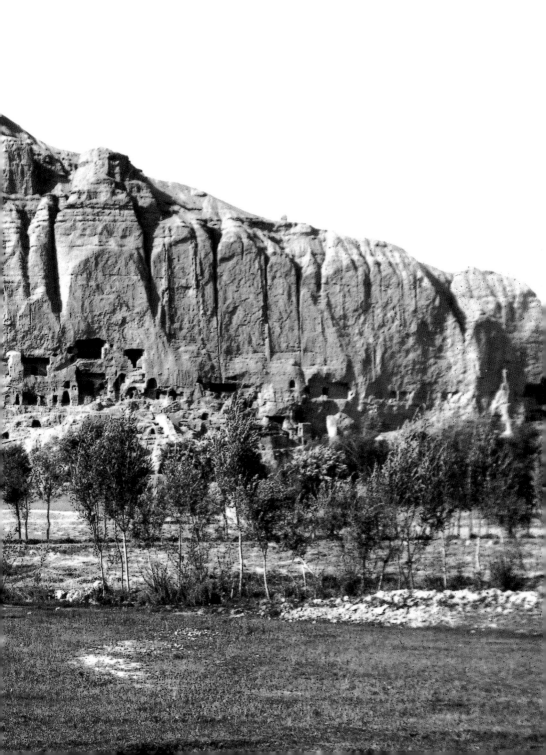

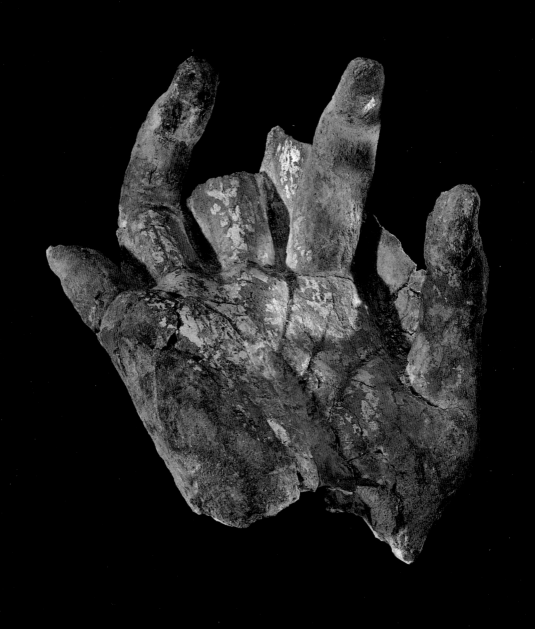

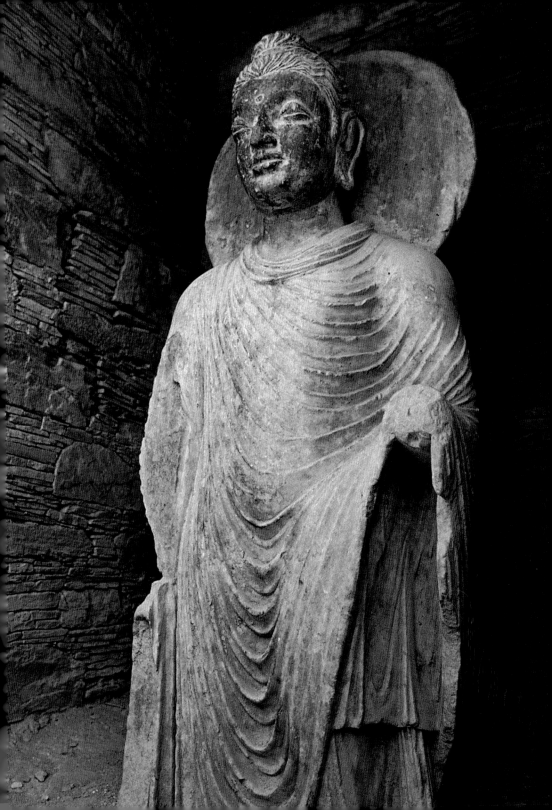

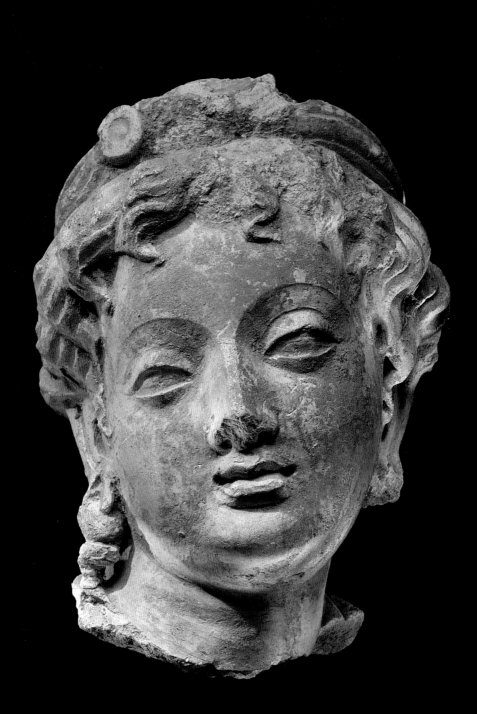

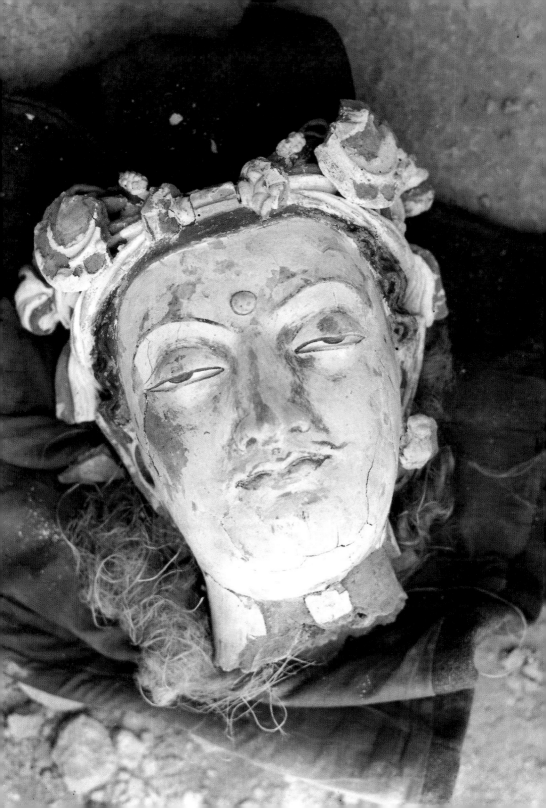

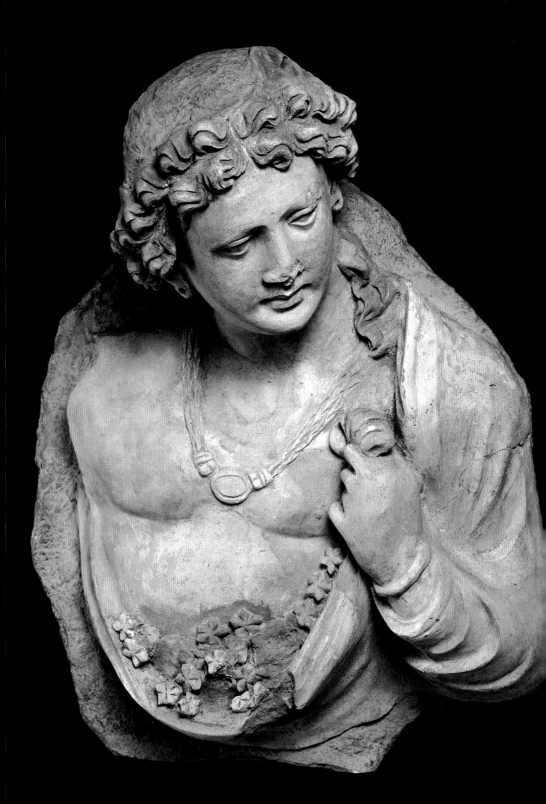

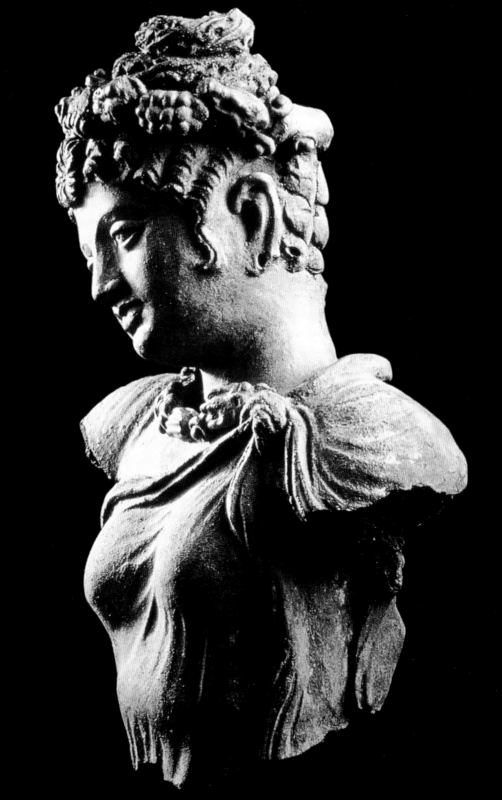

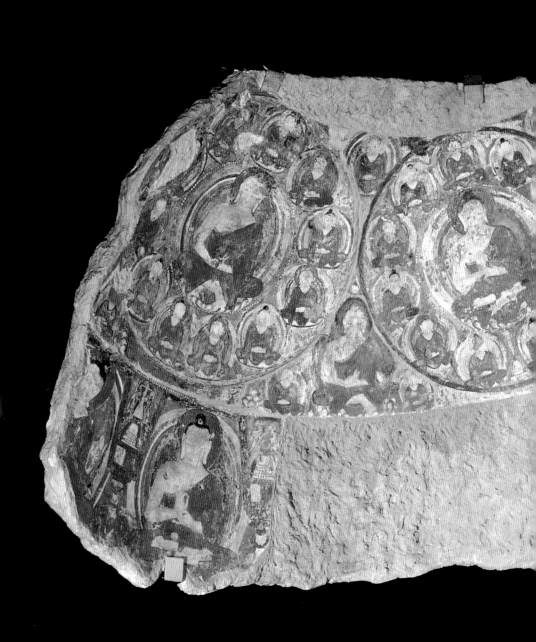

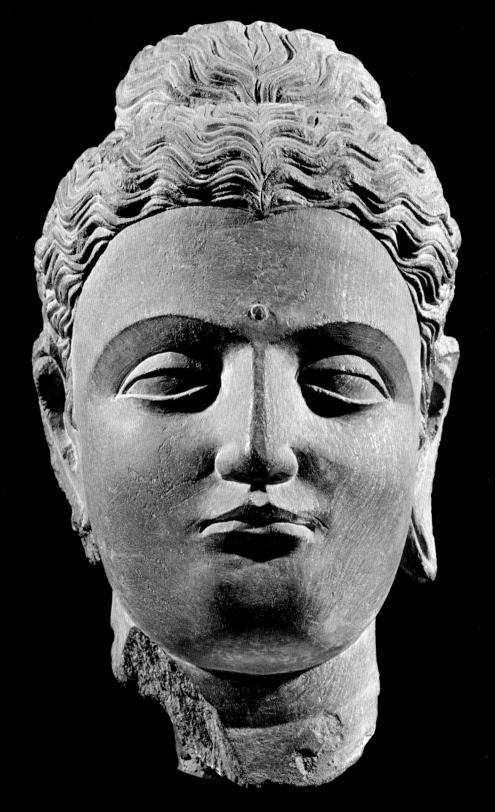

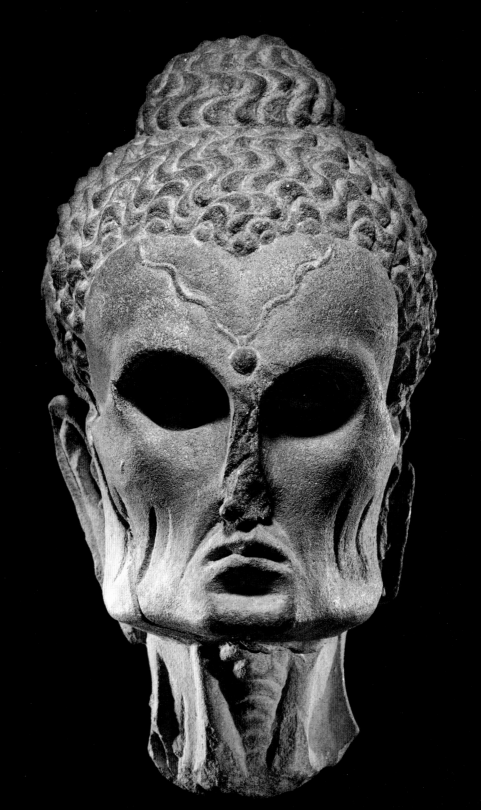

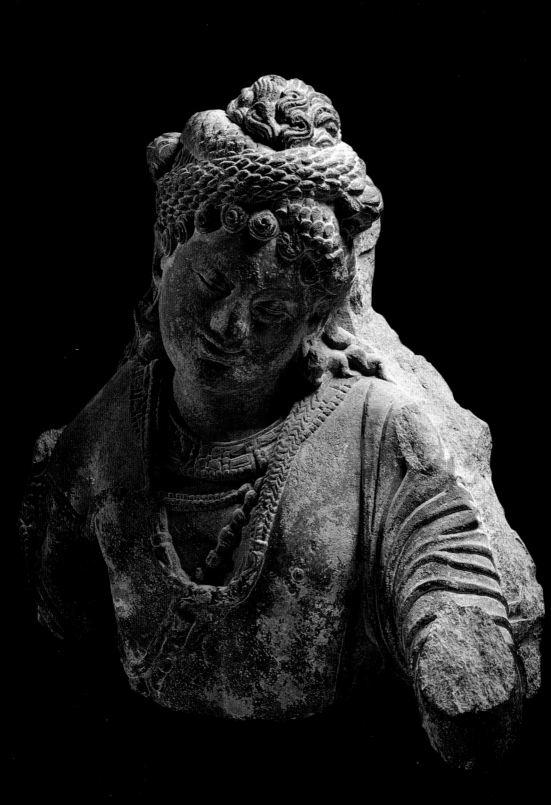

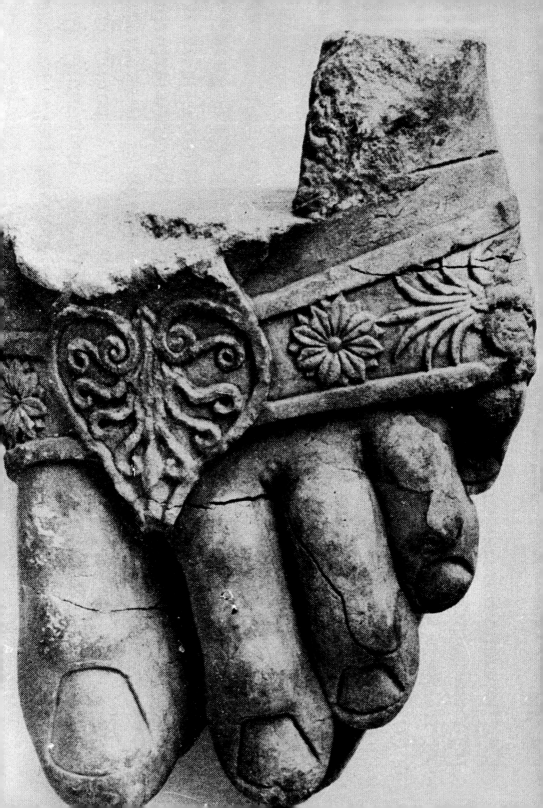

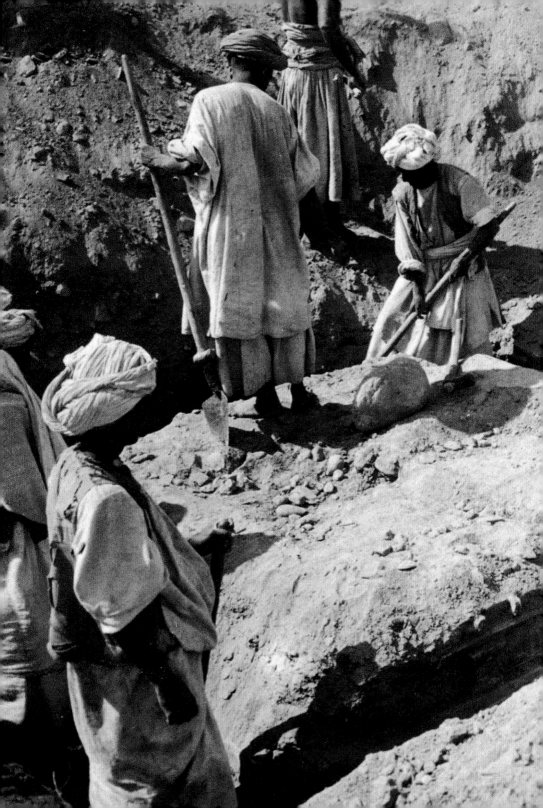

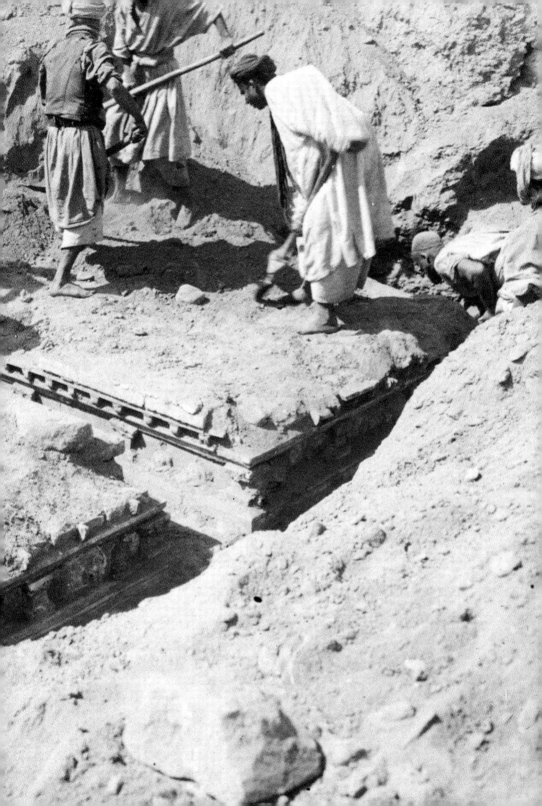

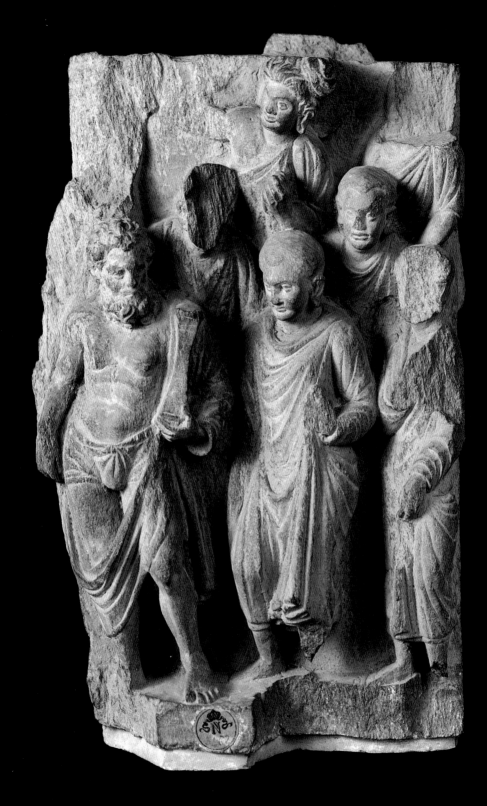

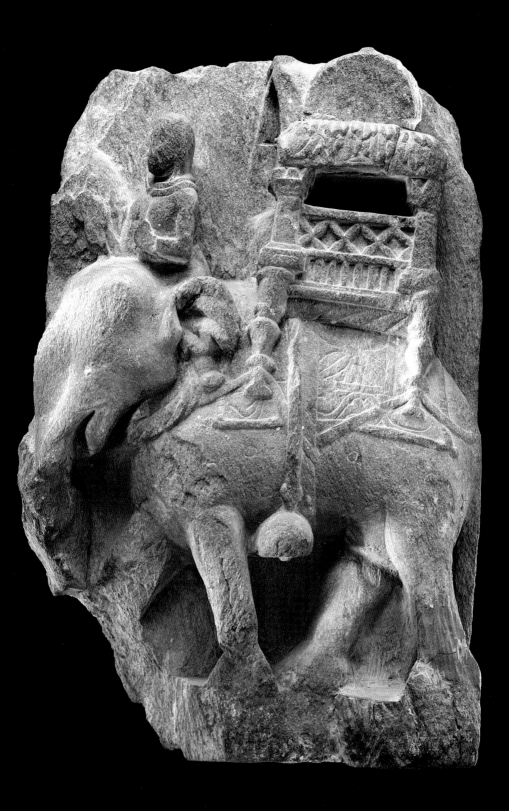

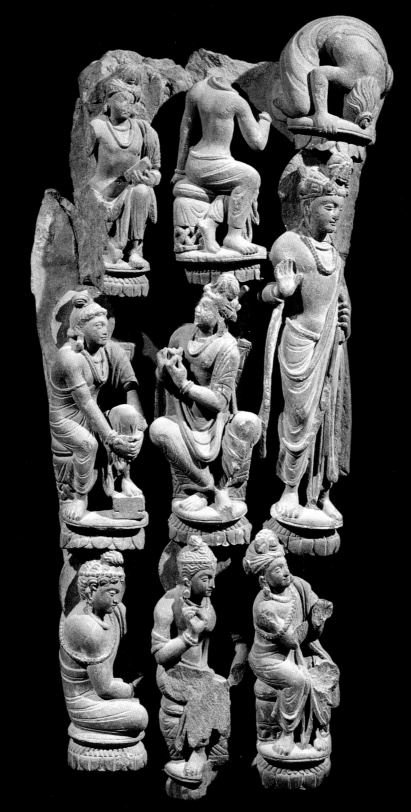

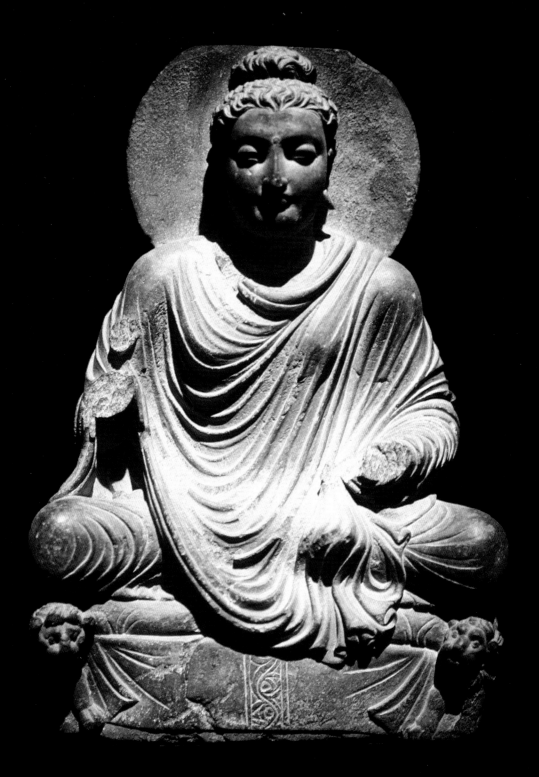

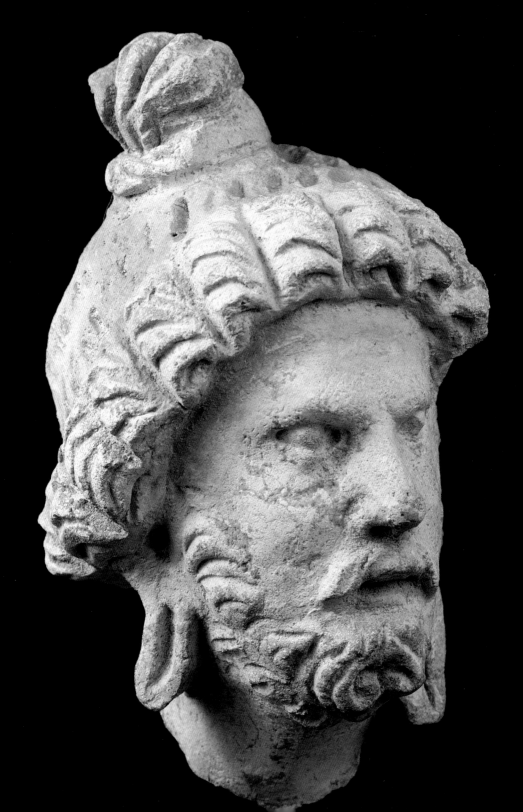

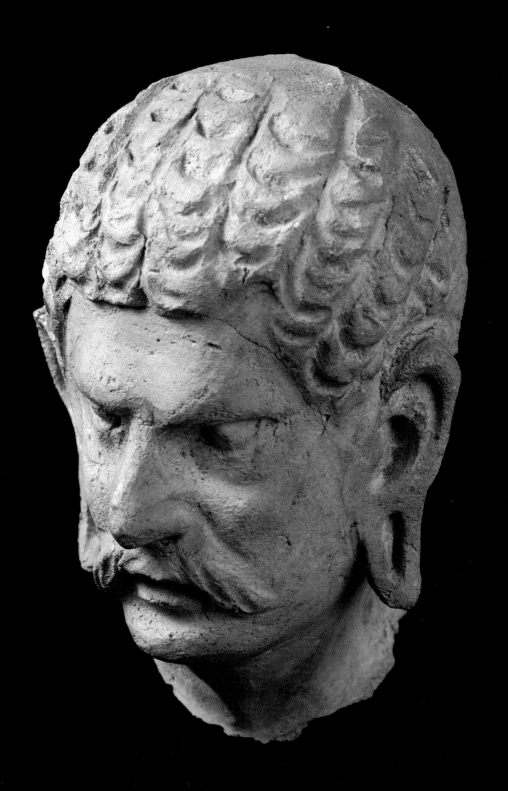

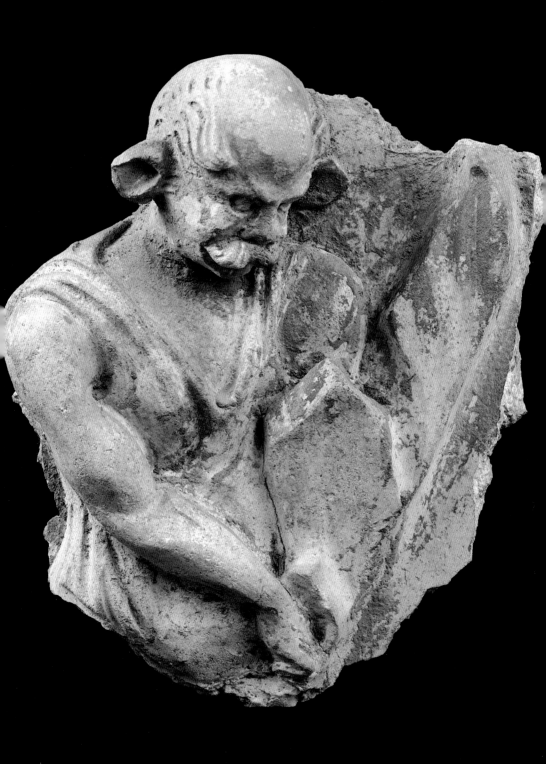

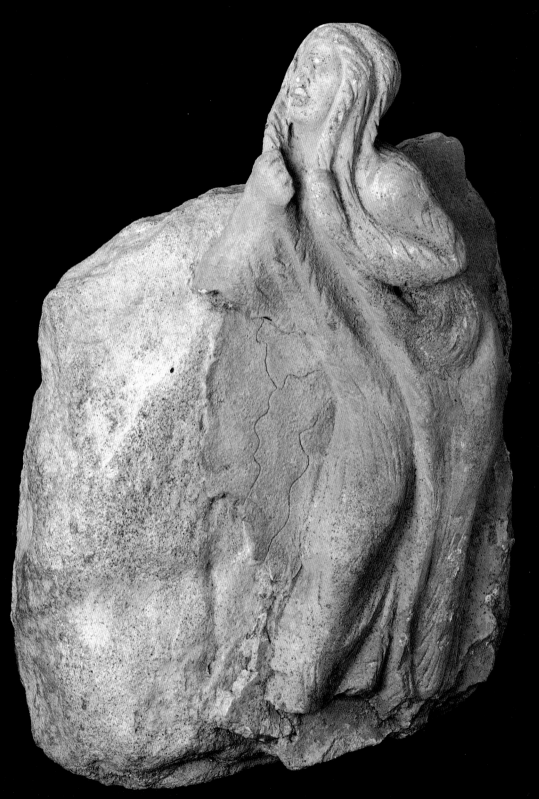

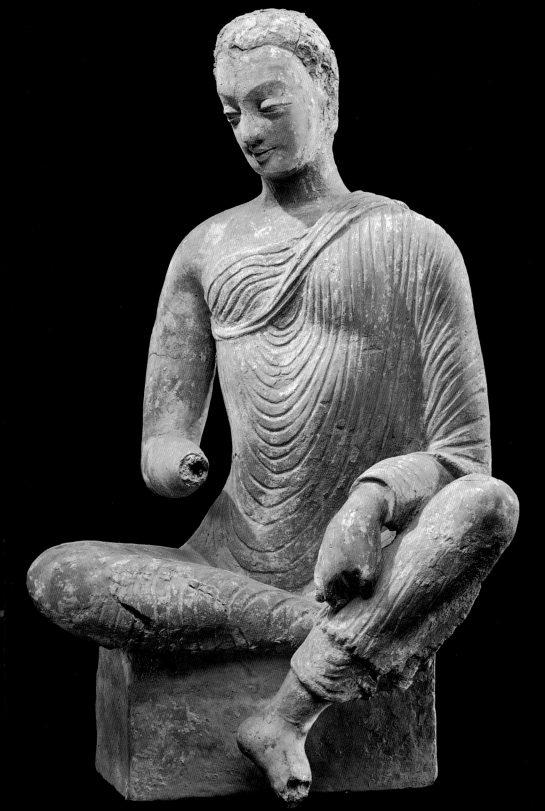

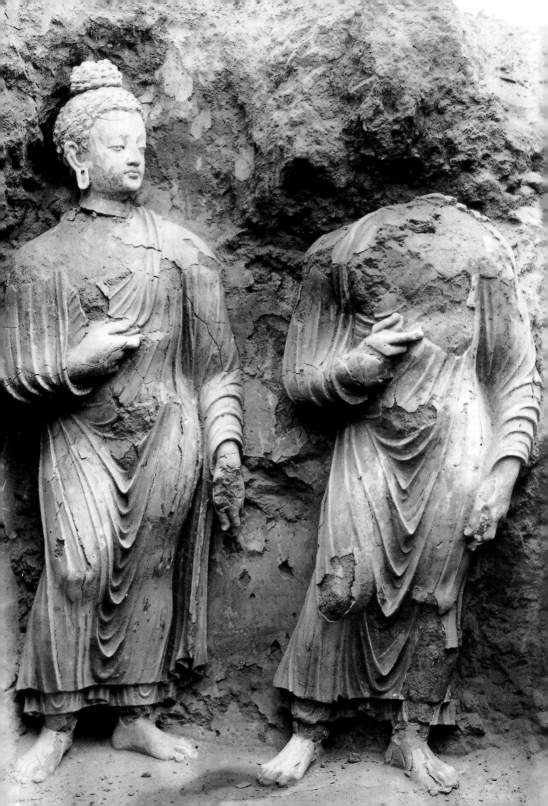

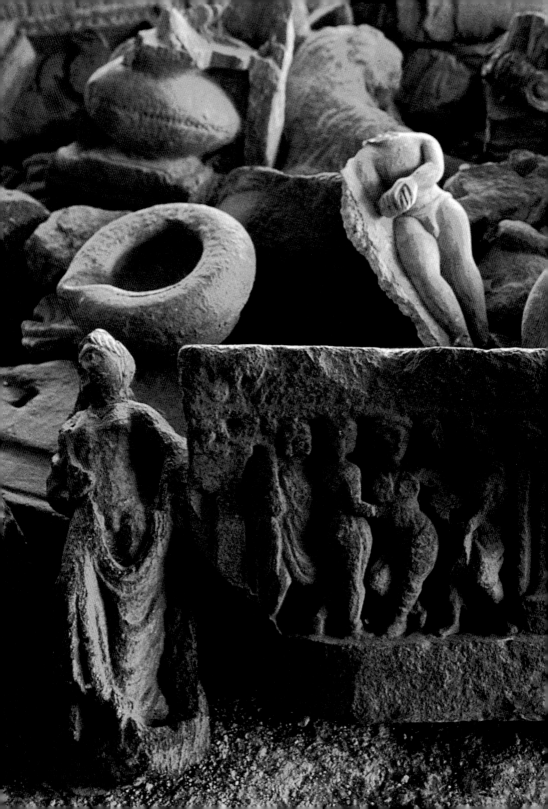

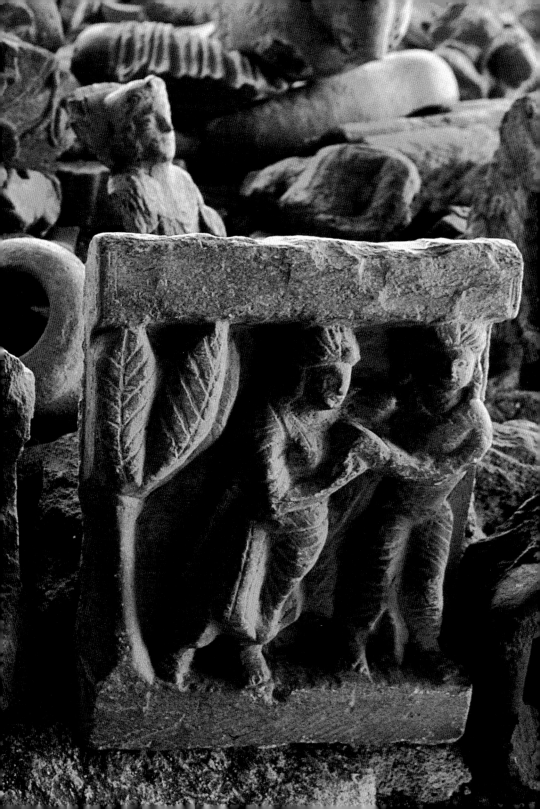

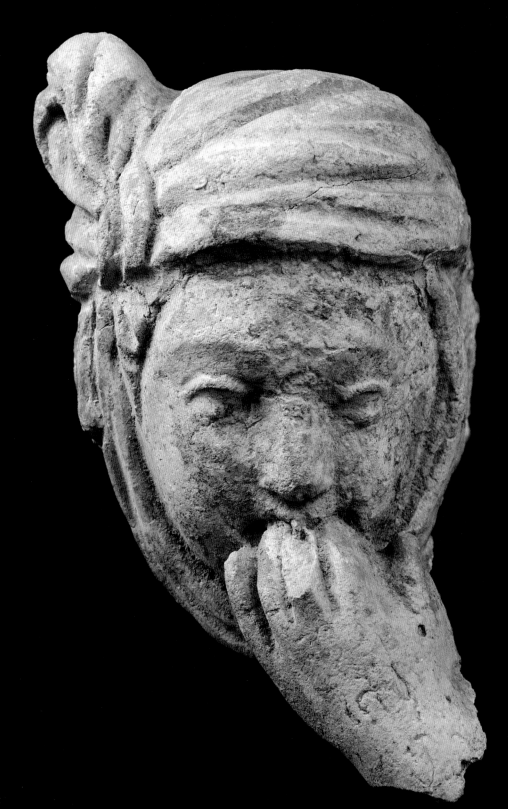

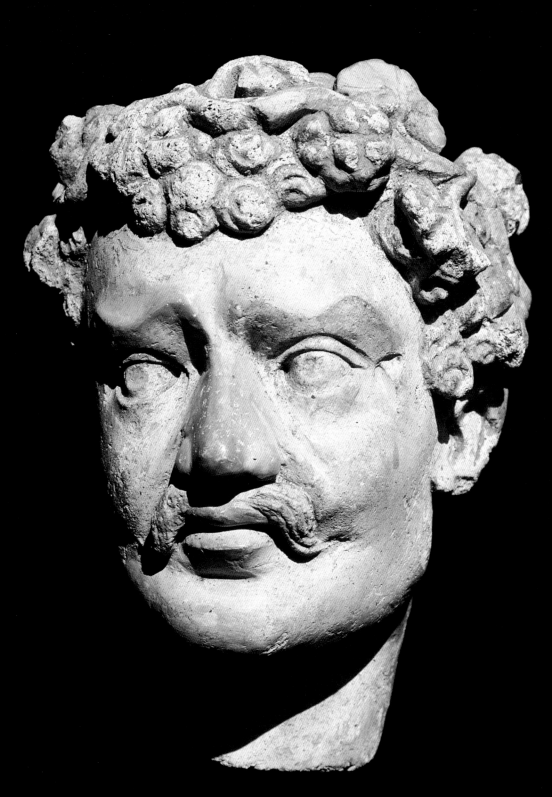

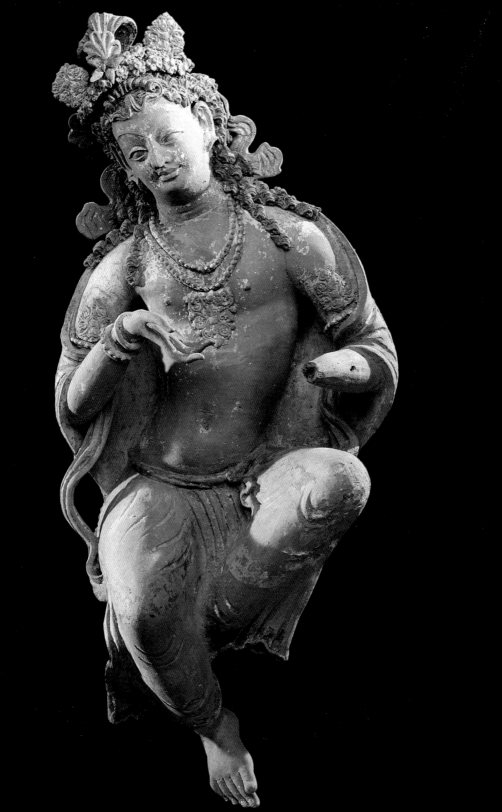

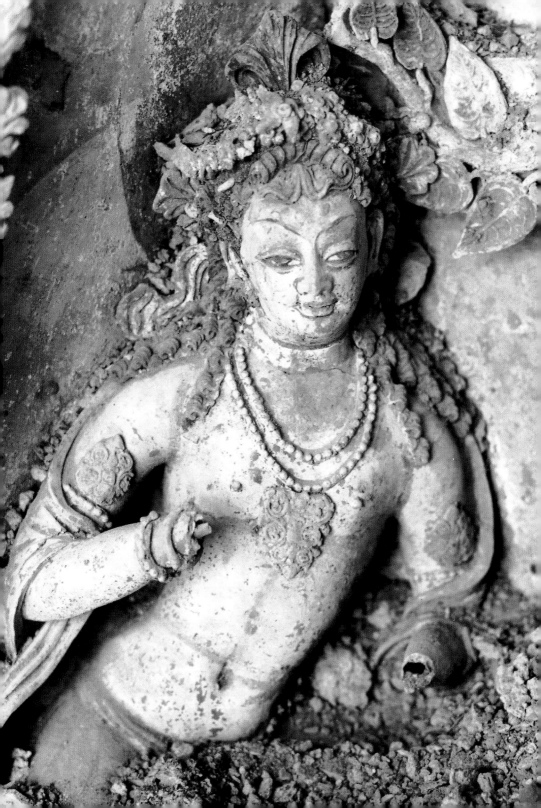

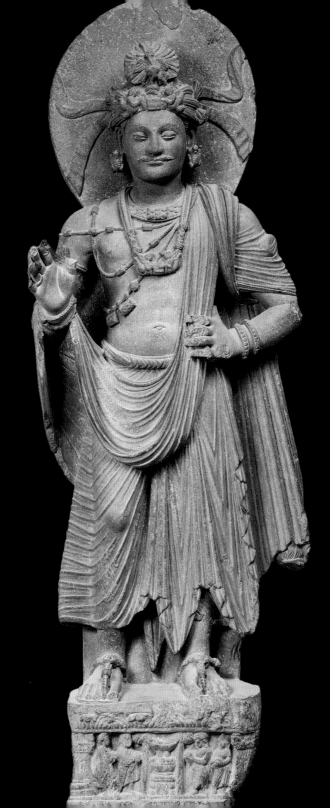

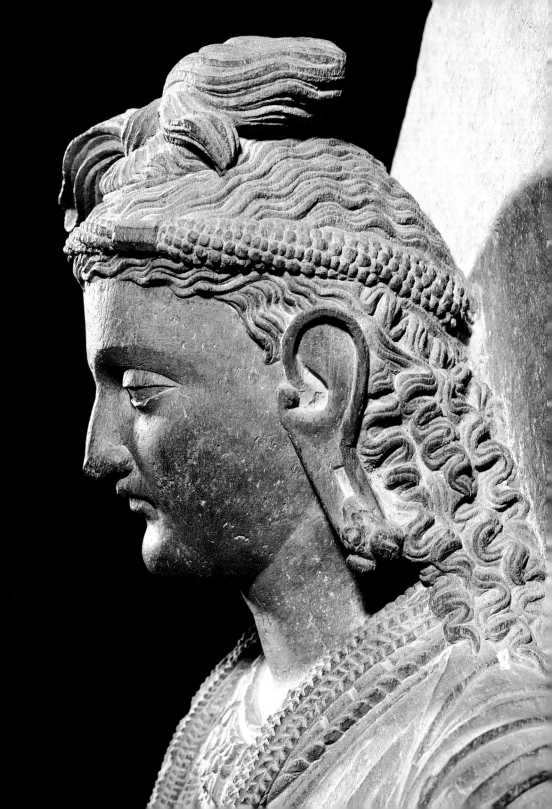

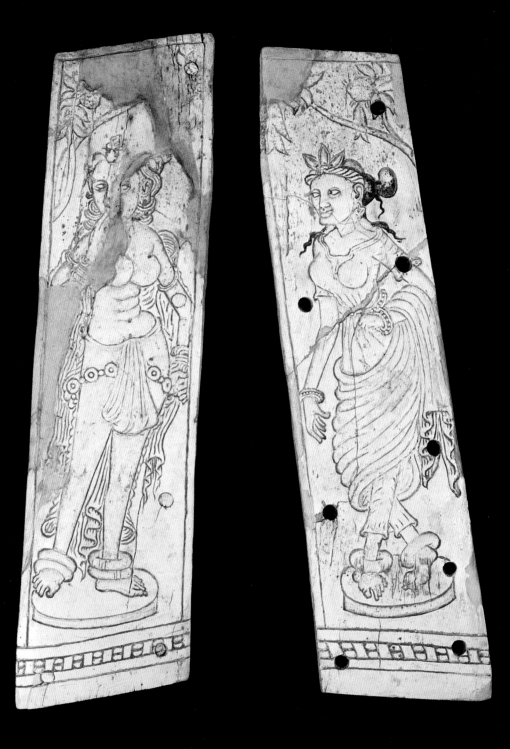

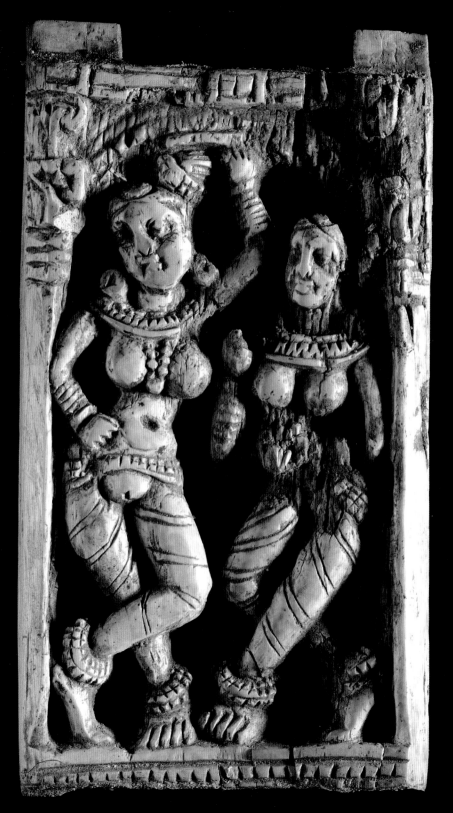

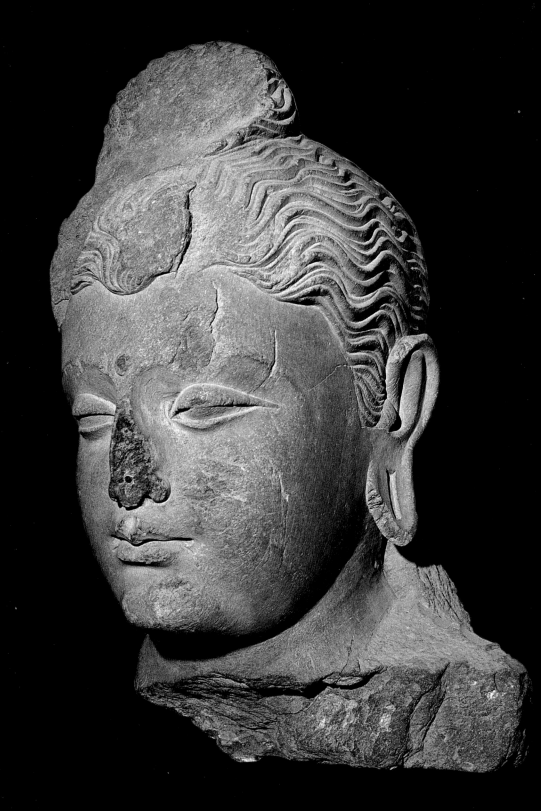

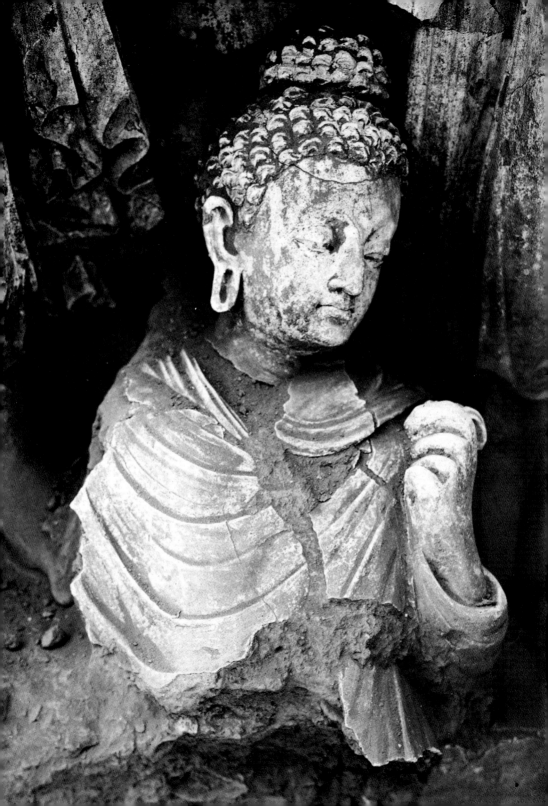

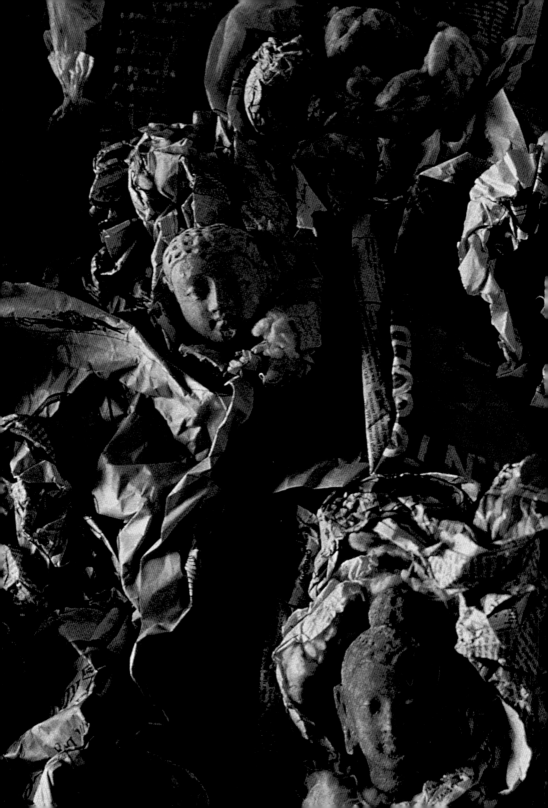

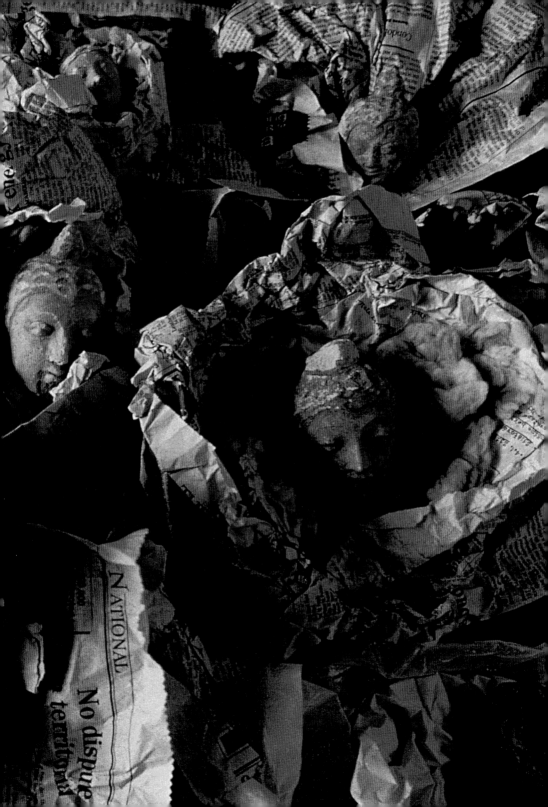

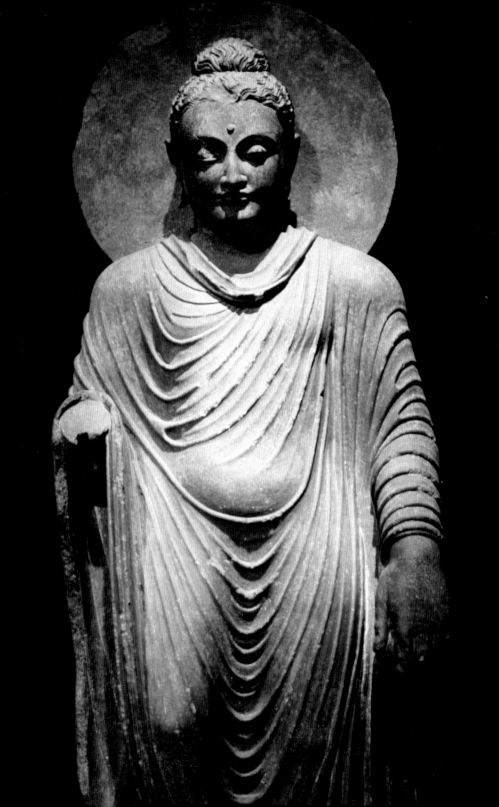

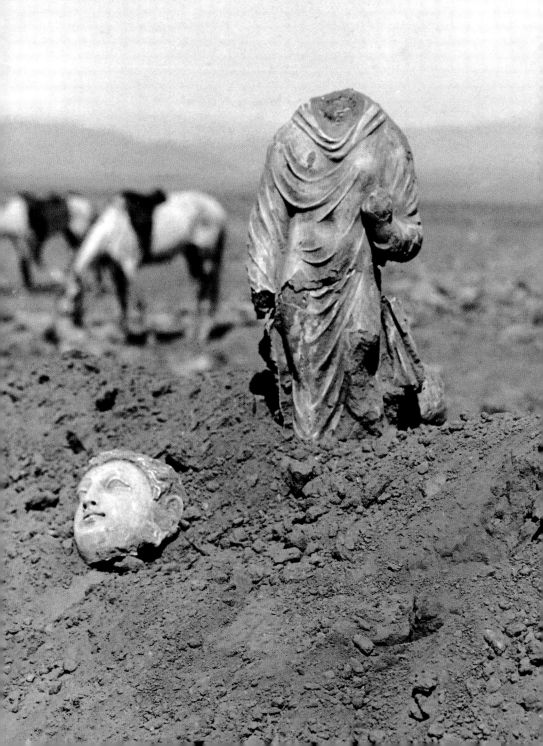

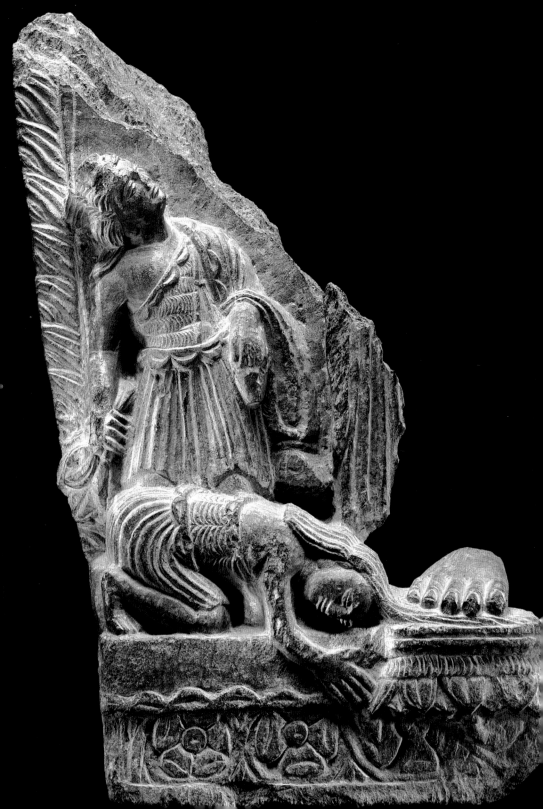

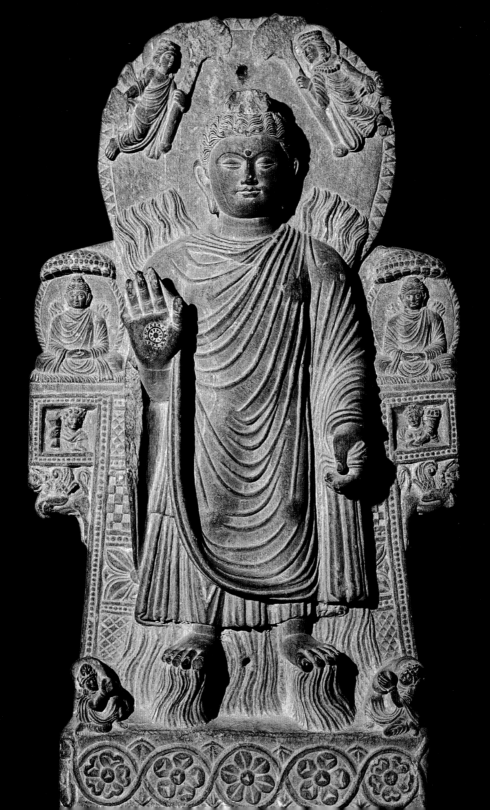

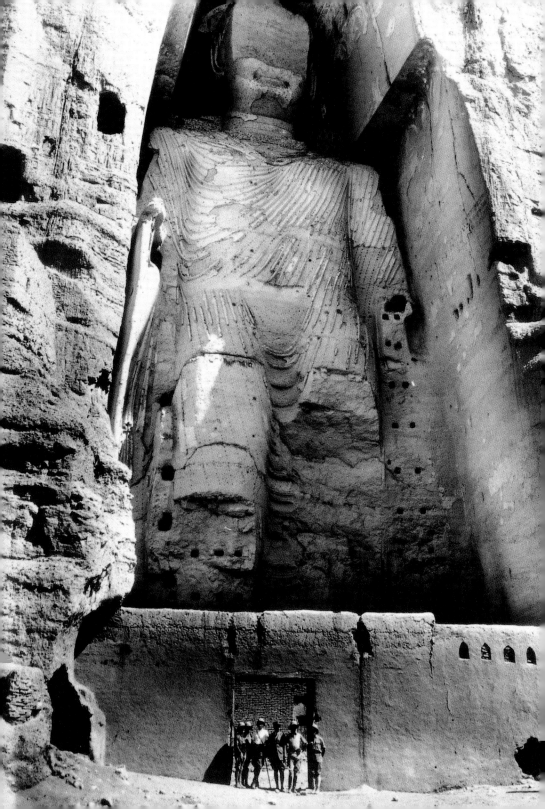

Scènes de la vie de Bouddha

Le Bouddha eut beau fait de dénoncer l'idolâtrie, un cortège d'images vit le jour quelques siècles après sa mort, qui illustrèrent avec une verve inouïe la geste du Bienheureux dans ses moindres détails. La palme de l'inventivité revient, sans conteste, aux sculpteurs du Gandhâra. Savoureuses "bandes dessinées" avant la lettre, les plaques de revêtement de leurs stûpas allaient offrir, pour de longs siècles à venir, un prodigieux catalogue d'images et de modèles aux praticiens d'Asie centrale, de la Chine et du Japon.

Naissance et jeunesse du prince Siddhârta. IIᵉ-IIIᵉ siècle. Schiste. Swat du Sud. Musée Guimet, Paris. © RMN. *(en haut, à g.)*
Celui qui allait devenir "Bouddha" ("l'Éveillé") serait né vers le milieu du VIᵉ siècle avant notre ère, dans la principauté de Kapilavastu, à quelque 240 km de Bénarès, aux confins du Népal actuel. Sa famille était de caste guerrière et appartenait à la lignée des Gautama. La légende raconte que c'est sous la forme d'un éléphant blanc que le Bouddha entra dans le sein de sa mère. Ressentant les premières douleurs de l'enfantement, la reine Mâyâ s'appuya sur la branche d'un figuier : de son flanc droit jaillit miraculeusement le prince Siddhârta appelé au plus grand des destins…
Le Grand Départ. IIIᵉ siècle. Schiste. Pakistan. Musée Guimet, Paris. © Photo Jean-Louis Nou/AKG Photo. *(en haut, à dr.)*
Élevé par la sœur de sa mère (emportée sept jours après sa naissance par une fièvre maligne) et par son père, le roi Shuddhodana, le jeune prince mène alors une existence heureuse au palais. Il fait preuve très tôt d'une intelligence et d'une force hors du commun.

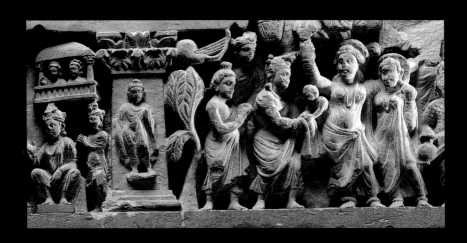

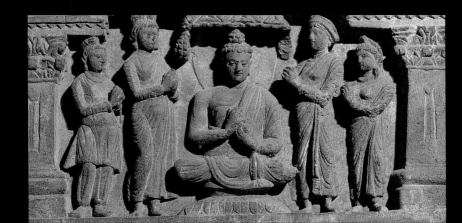

Cependant, quatre rencontres (un vieillard, un malade, un mort, un religieux) l'amènent à réfléchir sur la précarité et la souffrance de la condition humaine. À la vue des femmes endormies dans le palais (qui évoquent en lui le spectacle d'un charnier), Siddhârta renonce à sa condition princière pour devenir un religieux errant. Accompagné de son fidèle cocher Chandaka, il s'enfuit sur son cheval Kanthaka : c'est le "Grand Départ".

Bouddha en compagnie de disciples. IIIe siècle. Schiste. Musée Guimet, Paris. © Photo Jean-Louis Nou/AKG Photo. *(en bas, à g.)*
C'est dans le Parc aux gazelles de Sârnâth, non loin de Bénarès, que le Bouddha prononce son premier sermon et met en mouvement la Roue de la Loi. Pendant plus de quarante années, le Bienheureux fera entendre sa parole au hasard de ses pérégrinations et augmentera, de façon considérable, le nombre de ses fidèles.

Parinirvana de Bouddha. IIIe siècle. Schiste. Pakistan. Musée Guimet, Paris. © Photo Jean-Louis Nou/AKG Photo. *(en bas, à dr.)*
Sâkyamuni ne s'éteindra qu'à l'âge de quatre-vingts ans (probablement vers 480 av. J.-C.) à Kusînagara, le Kasia actuel. Sa mort, au milieu de ses fidèles, rappelle à bien des égards celle d'un autre sage de l'Antiquité, Socrate. De même que le philosophe grec interdit à ses disciples de le pleurer, Bouddha exhorta ses proches à ne pas désespérer. On remarque pourtant, sur ce bas-relief du Gandhâra, la douleur d'un assistant qui se lamente, les bras levés vers le ciel, selon le vieux schéma attesté en Asie centrale. À moins que cela ne soit là un souvenir du rituel des antiques pleureuses grecques...

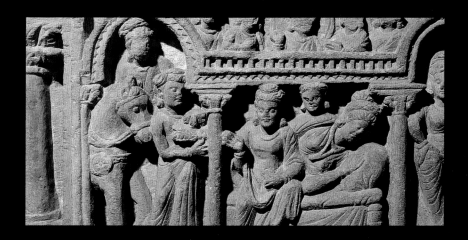

o

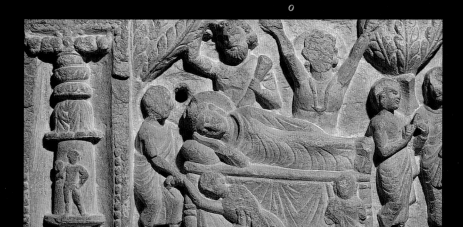

Chronology

Circa 560–480 B.C.: Birth and death of Gautama Buddha.

520 B.C.: First written mention of Gandhara in Bisutun, where it is cited among the regions subjugated by Emperor Darius the First.
Bactria, in turn, becomes part of the Achemenid empire.

327 B.C.: Alexander the Great pursues his conquest of western India.
Ai Khanum, the vast Hellenic metropolis on the banks of the antique Oxus river, is generally considered to have been founded around this time.

323 B.C.: Death of Alexander the Great. One of his lieutenants, Antigonos Monopthalmos, inherits the territories of Bactria and Carmania.

312 B.C.: The Gandhara region comes under the domination of the Indian Maurya dynasty.

305 B.C.: Seleucus Nicator abandons his designs on the regions situated to the south of the Hindu Kush. Nevertheless, many Greeks continue to live in these territories under the tutelage of the Maurya.

272 B.C.: The Indian emperor Asoka converts to Buddhism.
The religion of the Blessed One spreads throughout Gandhara.

239–238 B.C.: The Greek ruler Diodotus proclaims Bactria's independence.
This province on the fringe of Central Asia continues to assert its Greek culture.

232 B.C.: Death of Emperor Asoka.
A period of violent upheaval in India and Gandhara.

180 B.C.: Reconquest of Gandhara by Diodotus's nephew, Demetrius.

140 B.C.: Internecine struggles between the Greek Kings.
The Saka invade Bactria and Gandhara.

100 B.C.: Beginning of the decline of the city of Ai Khanum.

A.D 65: Ascendancy of the Kushan dynasty.
Gandhara develops trading links with the Roman Empire.

First century AD: Flowering of the Mathura school which, like in Gandhara, represents Buddha in human form.

125–140: Enthronement of Kanishka I, known as "the Victorious." A convert to Buddhism, this great Kushan emperor transformed Gandhara into a kind of "Holy Land" dotted with monasteries and stupas. The golden age of Buddhist sculpture.

240: Accession to the Sassanian throne of Shapur, who reigns until 272. The "Great Kushans" dynasty comes to an end, probably between 230 and 262.

350: Construction of stupas at Tape-Shotor, near Hadda.
Production in stucco replaces sculpture in stone.

Late fifth century: Gandhara falls into the hands of the Hephtalite Huns.

632: When the Chinese pilgrim Xuanzang visits Bamiyan, he marvels at the splendor of the two Buddhas carved in the cliff face. He notes the dilapidated state of the Buddhist monuments he encounters along the road through Gandhara.

Chronology based on the work of Mario Bussagli.

February 2001: Destruction of the two Buddhas of Bamiyan.

Joseph Hackin in front of a tent during the "Yellow Cruise."
Photo Citroën. Musée Guimet, Paris. © RMN.

Bibliography

General works:

BÉGUIN Gilles, *L'Inde et le monde indianisé au musée national des Arts asiatiques-Guimet*, Paris, Réunion des musées nationaux, 1992.

BUSSAGLI Mario, *L'Art du Gandhâra*, Paris, La Pochothèque, 1996.

BUSSAGLI Mario, *La Peinture de l'Asie centrale, de l'Afghanistan au Sinkiang*, Geneva, Albert Skira, 1978.

CHUVIN Pierre (ed.), *Les Arts de l'Asie centrale*, Paris, Citadelles & Mazenod, 1999.

FOUCHER Alfred, *L'Art gréco-bouddhique du Gandhâra*, Paris, 3 vol., 1905-1921-1950, out of print.

GIES Jacques and COHEN Monique (ed.), *Sérinde, terre de Bouddha. Dix siècles d'art sur la route de la Soie*, Paris, Réunion des musées nationaux, 1995.

TISSOT Francine, *Les Arts anciens du Pakistan et de l'Afghanistan*, Paris, Desclée de Brouwer-École du Louvre, "Les grandes étapes de l'art," 1987.

Travelers' and archaeologists' accounts:

Âges et Visages de l'Asie, un siècle d'exploration à travers les collections du musée Guimet, exhibition catalogue, musée des Beaux-Arts de Dijon, Paris, Réunion des musées nationaux, 1996.

HAARDT DE LA BAUME Caroline, *Alexandre Iacovleff, l'artiste voyageur*, Paris, Flammarion, 2000.

MAILLART Ella, *Des monts célestes aux sables rouges*, Paris, Payot, 1991.

MAILLART Ella, *La Voie cruelle. Deux femmes, une Ford vers l'Afghanistan*, Paris, Payot, 1991.

Le Voyage en Asie centrale. Anthologie des voyageurs occidentaux du Moyen Âge à la première moitié du XXᵉ siècle, Michel Jan (ed.), Paris, Robert Laffont, "Bouquins," 1992.

On the state of Afghan cultural heritage:

DE ROUX Emmanuel and PARINGAUX Roland-Pierre, *Razzia sur l'art. Vols, pillages, recels à travers le monde*, Paris, Fayard, 1999.

Main collections

Afghanistan:	Archaelogical Museum, Kabul
Germany:	Museum für Indische Kunst, Berlin
United Kingdom:	British Museum, London
	Victoria & Albert Museum, London
France:	Musée des Arts asiatiques-Guimet, Paris
India:	National Museum, New Delhi
Pakistan:	Lahore Museum
	Peshawar Museum

The archaeologist Jean Carl, a member of the DAFA team.
Photo Citroën. Musée Guimet, Paris. © RMN.

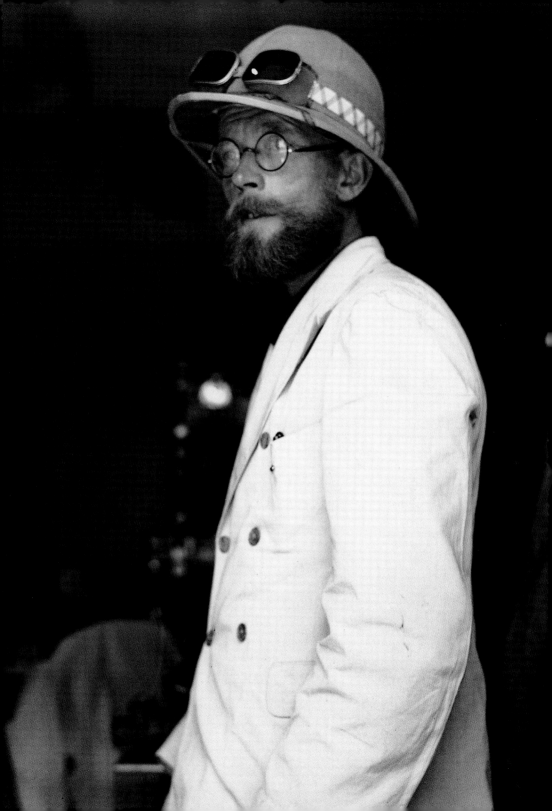

Gandhara

Fragment of a woman's face. Circa 7th–8th century. Mural painting, pigments on cob. Bamiyan, Grotto G, Hackin-Carl mission, 1930. Height: 3$^{1/3}$″. The painters and sculptors working in Bamiyan were probably of very diverse origin. Their art, with its Greek, Sassanian and Indian influences, in turn influenced other Central Asian schools. The sensual female features on this beautiful fragment are those of a devata (goddess). Musée Guimet, Paris. © RMN.

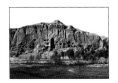

The cliff face at Bamiyan. Photographed by the DAFA in 1923. The west section with the niche of the 41.5-yard-high Buddha, surrounded by rock sanctuaries. The oasis at Bamiyan was an obligatory stopping point on the caravan route from Bactria to Taxila. The communities of Buddhist monks who flourished there for centuries had the cupolas and niches of their sanctuaries decorated by artists, but it was the two colossal Buddhas carved out of the rock, one 38 yards high, the other 58 yards high, which above all attracted pilgrims from all over the Buddhist world. Musée Guimet, Paris. © RMN.

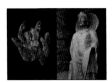

Monumental hand of a statue of Buddha. 7th century. Polychrome and gilded cob. Bamiyan. One can understand the Chinese traveler Xuanzang's amazement upon seeing this sculpture fragment coated in gold leaf. When he visited the city in 632, the Buddhas of Bamiyan still sparkled with myriad reflections. Musée Guimet, Paris. © RMN.
Statue from the monastery at Takhi-i-Bahi. Nothing could perturb the serenity of this beautiful Buddha, miraculously preserved from the ravages of time and war. © Photo Pascal Maistre/Gamma.

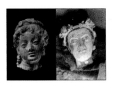

Head of a crowned woman. 4th–5th century. Stucco with traces of polychrome. Height: 6$^{1/3}$″. Hadda. Barthoux mission, 1928. The face of this woman-child, with her impish smile and unruly locks, illustrates the genius of the sculptors in clay working in Hadda. Is she a daughter of Mara, whose charms tested Buddha's resolve, or one of the wonderful devata peopling the Buddhist heavens? This distant relation of the Tanagra figurine heralds great gothic sculpture. Musée Guimet, Paris. © RMN. **A head brutally torn from its body,** shamelessly revealing its straw and cob entrails. Tepe, Marenjam. Musée Guimet, Paris. © RMN.

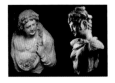

The "Spirit with Flowers" (a spirit carrying an offering of flowers). 3rd century. Stucco. Hadda. Mario Bussagli rightly stressed the strong classical influences discernable in certain Gandharan statues and compositions. The famous "Spirit with Flowers" was probably inspired by a model from the Hadrian period, the "Antinous Vertumnus." Musée Guimet, Paris. © RMN. **Statue of a woman from Hadda,** 4th–5th century. Probably from the Kabul Museum collection, this charming stucco head is one of the exceptional pieces that have recently appeared on the international art market. © Photo Pascal Maistre/Gamma.

Cupola of a cave decorated with Buddhas. 7th–8th century. Paint on cob. Height: 1.1 yard, diameter: 3.3 yards. Kakrak. Hackin-Carl mission, 1930. After its removal by the archaeologist Joseph Hackin in 1930, the cupola at Kakrak, one and a half mile southeast of Bamiyan, was divided between the Musée Guimet, Paris, and the Kabul Museum. Has the other half survived the bombardments and pillaging which have ravaged the Afghan capital? Musée Guimet, Paris. © AKG Photo.

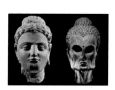

Head of Buddha. 5th century (?). Basalt. Pakistan. A blend of Greek influence (straight nose and curly hair) and Buddhist iconography (elongated ear lobes and cranial protuberance), this effigy of the Blessed One is a perfect Gandharan synthesis. Musée Guimet, Paris. © AKG Photo.

Mortification of Buddha. This head of the ascetic Buddha, with its almost macabre realism, is one of the most original works to have been created by the Gandharan sculptors. © British Museum, London.

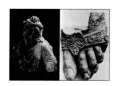

Bust of a bodhisattva. Schist. Pakistan. Like all bodhisattvas, this saintly figure postponing his Enlightenment is portrayed as a prince decked in heavy jewelry. Musée Guimet, Paris. © RMN.

Colossal marble foot of the "acrolythic" idol found in the redan-walled temple at Ai Khanum. Three times life-size, with Iranian-inspired decorative motifs on the sandal. Photograph from the DAFA archives. Musée Guimet, Paris. © RMN.

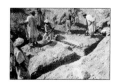

Excavating on the north side of Tapa Kalan monastery. Hadda. Godard mission, 1923. A godsend for the DAFA archaeologists: beneath the turbaned diggers, two stupas with their magnificent decorations still intact emerge from the sands of Hadda. Musée Guimet, Paris. © RMN.

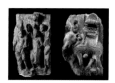

Vajrapani portrayed in his usual form, surrounded by Buddhist monks and musicians. 2nd century (?). Schist. Pakistan. In Ghandara's extraordinary cultural melting pot, artists did not hesitate to represent Buddha's companion, Vajrapani, as some bearded Heracles or Zeus of the Hellenic period. Musée Guimet, Paris. © RMN.

Elephant carrying a palanquin (transporting relics?). 4th century. Schist. Hadda. This high relief's religious inspiration is above all a pretext for a vigorous animal sculpture. Musée Guimet, Paris. © RMN.

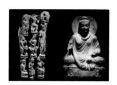

Gods and a bodhisattva. 4th–5th century. Mardan. This magnificent schist fragment, oscillating between delicate mannerism and a rare sense of anecdote, perfectly sums up the Gandharan genius. The extraordinary prostrated figure in the top right corner, possibly the young Sumegha spreading his hair over the ground beneath Dipankara Buddha's feet, is particularly striking. Musée Guimet, Paris. © AKG Photo. **Seated Buddha.** 2nd–3rd century. Gray schist. Takhi-i-Bahi. A marvel of poise, this Buddha, portrayed seated in meditation, attains the grandeur of an "icon." Museum für Indische Kunst, Berlin. © AKG Photo.

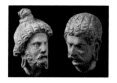

Head of a Brahmin. 2nd–4th century. Polychrome stucco. Height: 5$^{1/3}$". Barthoux Mission, DAFA, 1927. **Head of a "barbarian."** 3rd–4th century (?). Stucco. A striking portrait gallery of polychrome stuccos unhearthed in the Hadda. The man on the right, sporting torque and moustache, can't help but remind one of the famous sculpted Gauls at Pergamum, whereas the face on the left is that of a Brahmin or ascetic from the Indian world. Both: Musée Guimet, Paris. © RMN.

77

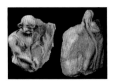

Half-length figure of a demon. 3rd–4th century. Stucco. Hadda. **Demon in a fur coat** (figure waiting for a mandarin to pass by). Stucco. Hadda. Verging on the macabre and surreal, these monsters, spawned in the imaginations of the Gandhara clay sculptors herald the gargoyles and other likeable demons so dear to gothic artists many centuries later. Both: Musée Guimet, Paris. © RMN.

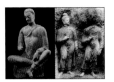

Buddha meditating. 7th–8th century. Polychrome dried earth. Jean Carl excavations, 1937. Height: 20". The strangely affected air of this young Buddha seated in regal relaxation is a far cry from the asceticism of Buddhism's beginnings. From the Buddhist monastery at Fondukistan, midway between Kabul and Bamiyan. Musée Guimet, Paris. © RMN.
Two Buddhas walking. Tapa Kalan, niche 144, Hadda. These two Buddhas, one acephalous, the other miraculously whole, were only waiting for the archaeologist's spade to see the light of day again. Musée Guimet, Paris. © RMN.

Gandhara bas-reliefs, models, cartoons and ranks of sculptures, like some extraordinary catalogue left any which way in the Takhi-i-Bahi monastery. Around 500 Buddhist monks lived at the foot of these mountains over 3,000 years ago. © Photo Pascal Maistre/Gamma.

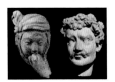

Head of a young man wearing a turban. 3rd–4th century. Stucco. Hadda. This beautiful head, rendered even more unreal by its decapitated state, evokes the gates of China. Musée Guimet, Paris. © RMN.
Head of a distressed (dying?) man. 3rd–4th century. Terracotta. Height: 8". There are echoes of Scopas in this admirable, tormented face, a worthy descendant of the greatest Greek sculptures of the 4th century B.C. National Museum of India, New Delhi. © Photo Jean-Louis Nou/AKG Photo.

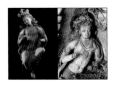

Devata (?) relaxing. 7th–8th century. Polychrome dried earth. Height: 28$^{1/3}$"; width: 9$^{1/2}$". Jean Carl excavations, 1937. Fondukistan. Dressed in Indian style in a dhoti with a scarf negligently draped over her shoulders, the ambiguous grace of this devata (?) is typical of the art of Fondukistan, which sought above all to please the eye. A certain Iranian influence is discernable in the "baroque" decoration of her hairstyle, with its cascades of flowing curls and dancing ribbons. On the right, a beautiful photograph of the same work from the DAFA archives. Both: Musée Guimet, Paris. © RMN.

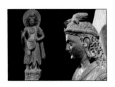

The "Foucher" bodhisattva. 2nd century. Schist. Pakistan. A magnificent bodhisattva removed from the monastery at Makha Sanda by Alfred Foucher in 1898, his right hand raised in the "fear-not" gesture. This figure, ribbons floating from its head, surrounded by an Iranian-influenced halo and bedecked with Scythian and Sarmatian-style jewelry, evokes the art of Palmyria rather than idealized Greco-Roman models. Musée Guimet, Paris. © RMN.
Head of bodhisattva Maitreya. 2nd–3rd century. Schist. Pakistan. Chandigarh Museum. © Photo Jean-Louis Nou/AKG Photo.

Standing female figures. 2nd–3rd century. Incised ivory plaques, part of a casket (left) and a plaque decorated in openwork high relief (right). Afghanistan. Joseph Hackin and his DAFA colleagues made one of their most remarkable discoveries at Begram (Kapisa in Antiquity). Amidst Chinese lacquers, Hellenic bronzes and glassware from Alexandria and Syria, lay magnificent carved ivory plaques, whose extreme sensuality was clearly Indian in origin—a perfect summary of the rich caravan routes of Central Asia. All three: Musée Guimet, Paris. © RMN.

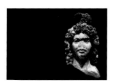

Prince Siddhartha (?). 2nd–3rd century. Marble. Height: 23". Found in the Peshawar region. Sculpted in a beautiful white marble—extremely rare for this region—this striking portrait depicts Prince Siddhartha before he attained Enlightenment. Voluntarily "baroque" treatment, this effigy derives from late portrayals of deified Roman emperors rather than the Apollonian canon. George Ortiz collection. © AKG Photo.

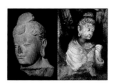

Head of a monumental Buddha. 3rd century. Schist. Part of a large statue. Kharkai. Height: 16¹/²". Foucher mission, 1895–97. Ghandaran art, so often reduced to more or less narrative bas-reliefs, sometimes attains heights of refinement in its quest for monumentality. The effigy of the Blessed One has been transformed here into a meaningful and stylized image of the benevolence, concentration, gentleness and serenity of a being absorbed, eyes half-closed, in an unfathomable universe. Musée Guimet, Paris. © Photo Jean-Louis Nou/AKG Photo. Bust of a buddha from Tapa Kalan. Musée Guimet, Paris. © RMN.

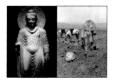

The sad fate of the Kabul Museum collections: smashed, mutilated, destroyed or pillaged to feed the international traffic in artworks. Occasionally fragments crop up unexpectedly, like this incredible collection of decapitated Buddhas' heads wrapped in newspaper, stolen from the Kabul Musem and refound in Peshawar. Photographed in Pakistan in June 2000. © Photo Pascal Maistre/Gamma.

Standing Buddha. 2nd–3rd century. Gray schist. Takhi-i-Bahi. This effigy of the Blessed One, hieratic like a Greek kore, probably stood against a wall of a chapel or religious edifice. Draped in a monastic mantle rippling with folds, the Enlightened One, absorbed in profound meditation, seems to have transcended the world of appearances. Museum für Indische Kunst, Berlin. © AKG Photo.
Statue found in the Tapa Kalan monastery. Niche 144, Hadda. Photographed by the DAFA. Musée Guimet, Paris. © RMN.

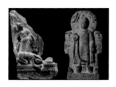

Sumegha prostrated. 3rd–5th century. Gray schist. Height: 6¹/⁴". Shotorak excavations, 1936–37. A surrealistically fragmented representation of the legend of the young Sumegha prostrating himself to spread his hair beneath the feet of Dipankara, one of the Buddhas of the past. A symbol of abandonment in devotion. © RMN. The Sravasti miracle. 4th century. Schist. Buddha is depicted here performing the "Great Miracle of Sravasti," flames leaping from his shoulders and water flowing from his feet. Enough to convince every Saint Thomas in India and China! © AKG Photo. Both: Musée Guimet, Paris.

"La Croisière jaune." The PAMIR group in front of the great Buddha at Bamiyan. The minute figures of the legendary "Croisière jaune" posing for posterity at the foot of great Buddha carved out of the rock face. Photograph: Citroën. Musée Guimet, Paris. © RMN.

WITHDRAWN

The author would first like to express her profound gratitude to her parents, without whom she would never have known the beautiful land of Afghanistan. She would also like to thank Martine and Prosper Assouline, her publishers, for their continuing confidence in her, Julie David for her constant enthusiasm, Jérôme Ghesquière for having so kindly opened up the treasure trove of the Musée Guimet's photo library for her, and of course Laurent and Cassandre Schneiter, who were, as always, closely involved in this project.

The publisher would particularly like to thank Dominique Fayolle and Jérôme Ghesquière at the Musée Guimet, Paris. Many thanks also to Carol White (British Museum, London), Bernard Garett and Hervé Mouriacoux (AKG Photo, Paris), Caroline de Lambertye (photographic archives of the Réunion des Musées Nationaux, Paris), M. Lounès (Gamma, Vanves), and the photographer Thierry Ollivier, for their aid in preparing this publication.